MICK JAGGER

© 2011 Contrasto Due srl
Via degli Scialoja, 3
00196 Roma
www.contrastobooks.com

In collaboration with
Les Rencontres d'Arles. Photographie

Published on the occasion of the exhibition
Mick Jagger. The photobook

Project manager: François Hébel
Picture research: Wissam Hojeij
Production: Eva Gravayat, Prune Blachère.
Design: Daniele Genchi
Text research: Franca De Bartolomeis
Illustrations: Umberto Mischi
Distribution of the exhibition: Fondazione Forma per la Fotografia

For the texts © the authors
We would like to thank Mick Jagger, Jean Pigozzi, Tony King, Tamsin Lion, Maja Hoffmann,
Claude Gassian (also for the loan of the serigraph by Andy Warhol).
For the photographs ©: © Bryan Adams / CAMERA PRESS; © Brian Aris / CAMERA PRESS; © Enrique Badulescu;
© Cecil Beaton Studio Archive at Sotheby's; © Simone Cecchetti; © Willie Christie / www.williechristie.com;
© Anton Corbijn; © Kevin Cummins / DALLE; © Sante D'Orazio; © Deborah Feingold; © Tony Frank / www.tonyfrank.fr;
© Claude Gassian; © Harry Goodwin / Davebrolan.com; © Anwar Hussein / Getty Images; © Karl Lagerfeld;
© Annie Leibovitz; © Peter Lindbergh; Gered Mankowitz © Bowstir Ltd 2010 / mankowitz.com;
© Jim Marshall / marshallphoto.com; © David Montgomery / Scream Gallery, London; © Terry O'Neill / Getty Images;
© Guy Peellaert; © Jean-Marie Périer / Courtesy of Galerie Photo 12; © Michael Putland;
© Ken Regan / camera 5-Retna / DALLE; © Herb Ritts / Herb Ritts Foundation;
© Ethan Russell, All Rights Reserved / La Galerie de l'Instant; © Francesco Scavullo / scavulloeditions.com;
© Norman Seeff; © Mark Seliger; © Dominique Tarlé / La Galerie de l'Instant; © Pierre Terrasson; Founding Collection,
The Andy Warhol Museum, Pittsburgh © The Andy Warhol Foundation / Adagp, Paris 2010; © Albert Watson;
© Robert Whitaker; © Baron Wolman

ISBN: 978-88-6965-290-5

MICK JAGGER
THE PHOTOBOOK

contrasto

LES RENCONTRES D'ARLES
PHOTOGRAPHIE

Portrait of a Star: a Photographic Challenge

Mick Jagger is universal. His unmistakable face has made him the archetypal rock star. His charisma has fuelled the admiration and passion of his fans, the way he moves his body has shaped the myth of male celebrity, and his lips have become the logo of his band, the Rolling Stones. Jagger has had one of the longest careers in rock, and to promote his music, he has collaborated with many top photographers for press shoots, album covers and posters.

In the theatre, people speak of unity of place and time. In order to consider the rock portrait, we have chosen to focus on different unities; unity of face, in the form of Mick Jagger, and unity of genre – the posed portrait, as opposed to stage photography or candid shots. While we certainly hope that this collection will thrill Mick's fans, this is primarily intended as a photography book. His face tells the story of fifty years of portrait practice, speaking of our relationship with celebrities, of evolving fashions, and of the creation of a rock aesthetic. As we journey through the years, we can almost hear the music.

In the early sixties, Gered Mankowitz and Jean-Marie Périer (working for French teen magazine *Salut les Copains*) photographed Mick when his mouth was still a childlike pout. Meanwhile, Cecil Beaton, that giant of portrait photography, loved to try out different locations and stagings for every shoot. In the same era, David Bailey (who declined to take part in this project) produced tightly framed portraits

in which the iconic importance of the fledgling star's face could already be sensed. All of them seemed to work freely and easily with their subject. An aesthetic was being born.

The images of the seventies are marked by their variety. Some evoke total abandon, the explosive side of rock, the exhausted star coming off stage after giving himself utterly to his fans. Other more posed pictures reflect the rise of flower power, surrounding Jagger with imagery often more associated with Bob Dylan or Donovan. This was a fast-moving time in the music industry. David Bowie and Lou Reed were on the rise and a more theatrical aesthetic rose with them, requiring the enlistment of fashion designers, hairdressers and make-up artists. Terry O'Neill, Michael Putland and Jean-Marie Périer portray Jagger as an androgynous dandy, Guy Peellaert makes him a key figure in *Rock Dreams*, the legendary book of photorealist paintings, and Andy Warhol pays tribute to the star in a famous series of screenprints.

Curiously, it is not until the eighties that we see photographers such as Enrique Badulescu, Herb Ritts and Pierre Terrasson asking Jagger to strike his dynamic stage poses in the studio. Never had his mouth seemed so big and his swagger so pronounced; it almost became a trademark, like his lips. In Deborah Feingold's portrait, he is even recognizable behind a mask. Claude Gassian, keeping a discreet distance, catches the star in a hotel lobby, the first of a series of magnificent portraits.

The nineties bring images influenced by the latest in fashion photography. In works by Sante d'Orazio, Peter Lindbergh, Karl Lagerfeld and others, Jagger becomes an aristocratic figure, the epitome of gentlemanly elegance and laidback refinement, albeit with a touch of irony. Anton Corbijn uses devilish accoutrements to create a striking effect, while Albert Watson pushes back the boundaries of excess with a remarkable image that transforms Mick Jagger into the most beautiful of big cats. Annie Leibovitz, who made her name working for *Rolling Stone* before joining the prestigious *Vanity Fair*, has had a long and intense relationship with the band, shooting portraits and album covers. In her many images of Jagger, we can see the evolution of her personal style, moving from pure and intuitive portraiture through to high-concept imagery, and then to a more restrained approach once more.

In the early 21st century, photo shoots became a rarer commodity. Jagger still grants one occasionally, to satisfy the constant demands of the press, but no longer seems willing to devote much time to them. There are three portraits by Karl Lagerfeld; Mark Seliger and Simone Cecchetti show a face that is still appealing but also more thoughtful, its character emphasized by the marks of time. Anton Corbijn seems to share a playful, conspiratorial relationship with his subject, as does Bryan Adams, a world-famous musician in his own right. Jagger is now presented in a straightforward fashion, without artifice, costumes, masks or make-up. He has confidence in his own presence and in his own face, which has been rendered mythical by the photographer's lens.

It is hard for a stage photographer to rise above the performance, the sets and the costumes to create a purely photographic work. The power, charm and notoriety of Mick Jagger's face are the very essence of what it is to be photogenic. To do more than simply record this intense and dramatic personality: that is the very real challenge that photographers have been tackling for the last fifty years.

<div style="text-align: right">

François Hébel
Exhibition curator
Director of Les Rencontres d'Arles

</div>

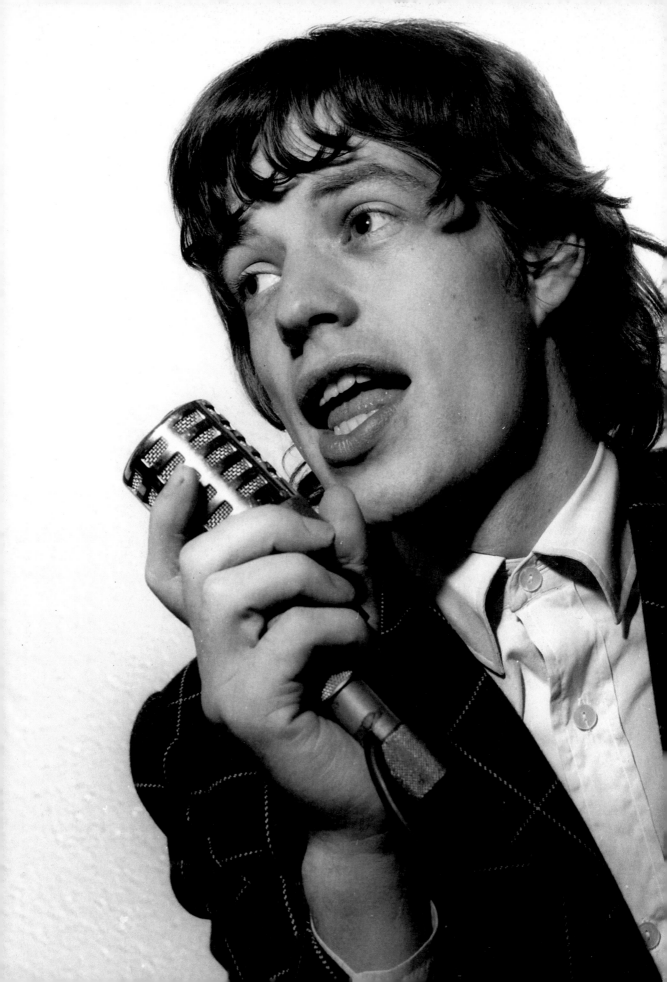

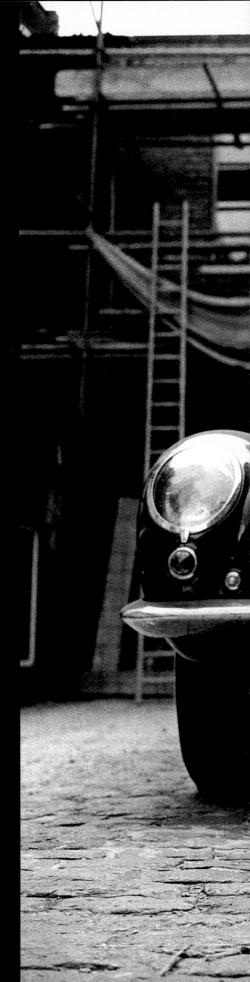

Harry Goodwin
Manchester, 1964

Gered Mankowitz
London, 1966

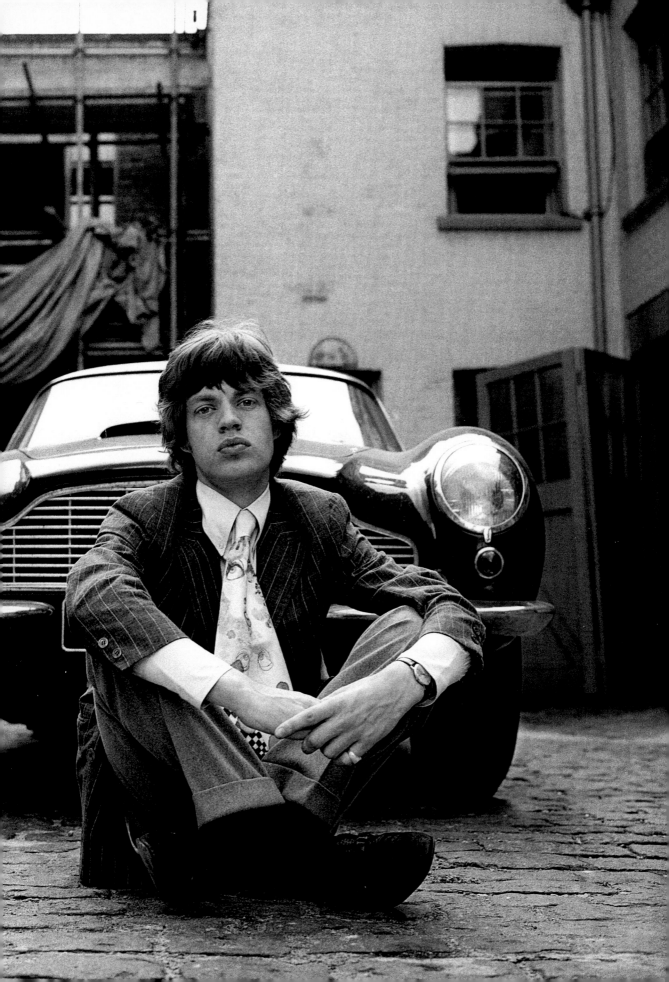

Gered Mankowitz
London, 1966

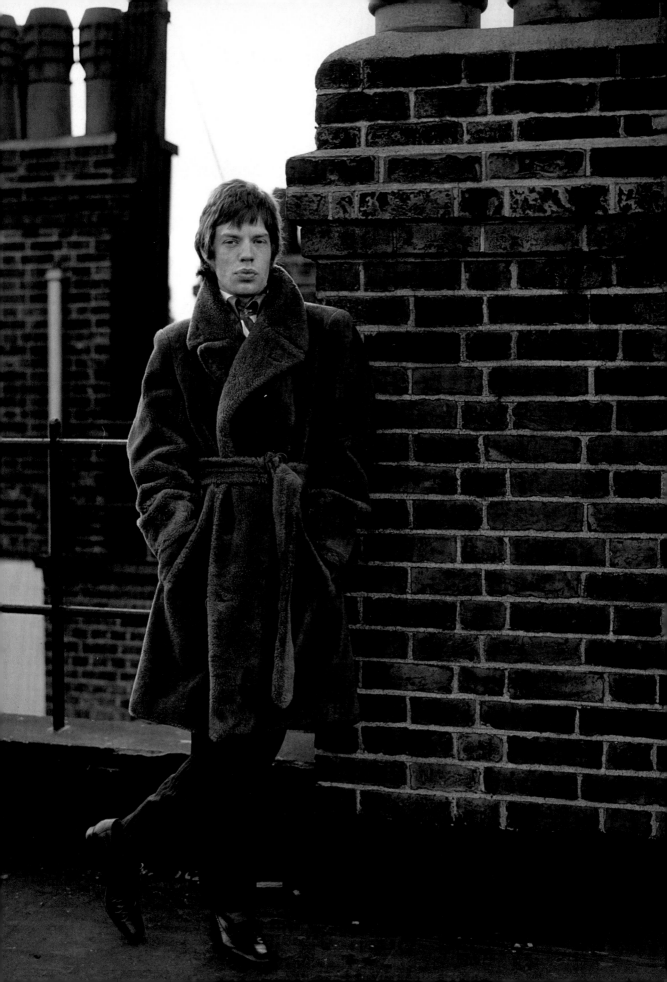

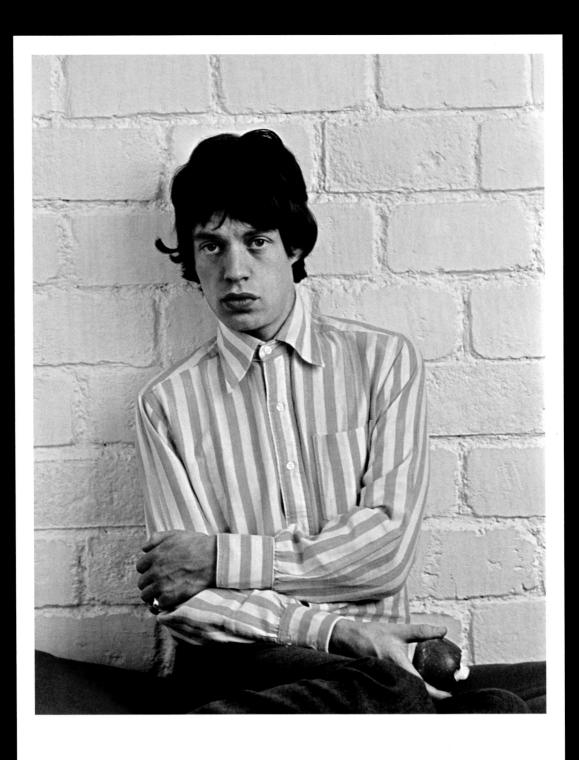

Jean-Marie Périer
Paris, 1966

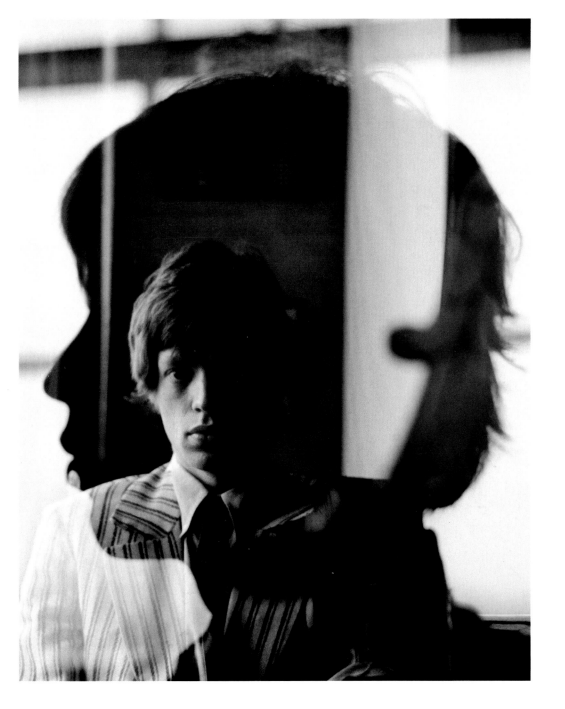

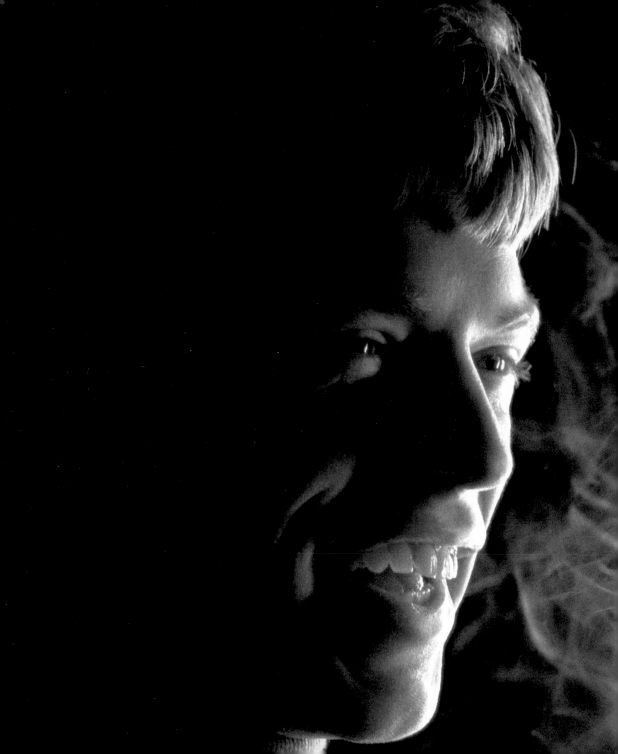

Jean-Marie Périer
Paris, 1966

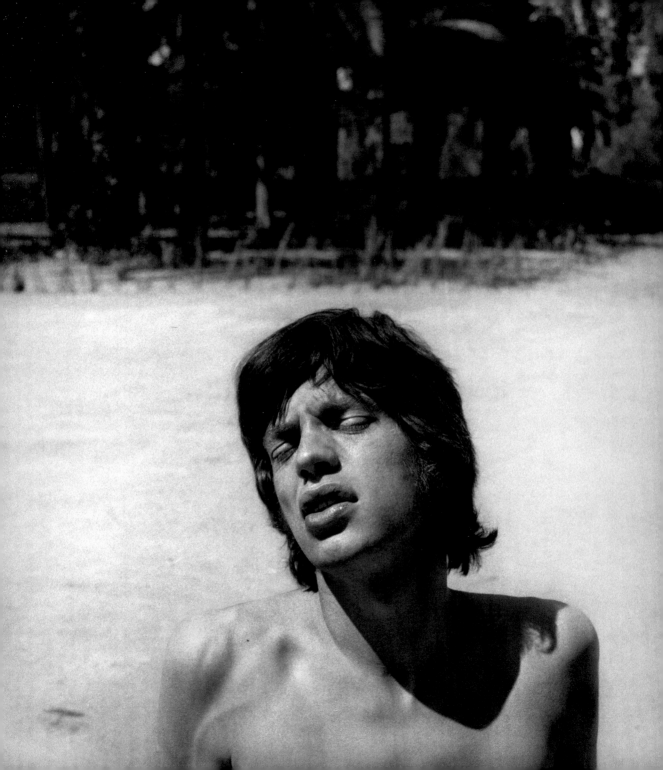

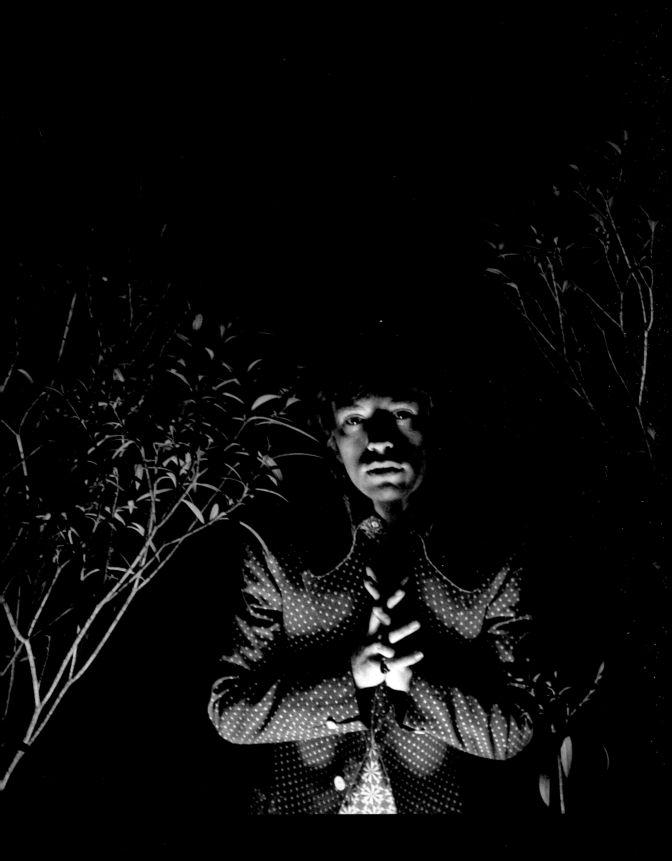

Cecil Beaton
Marrakech, 1967

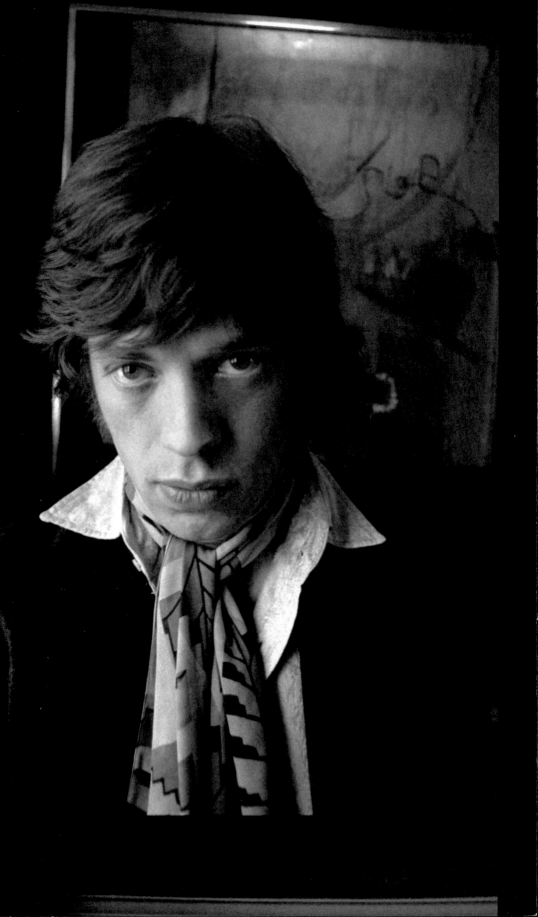

Cecil Beaton
April 1967

Gered Mankowitz
1967

Cecil Beaton
On the set of
"Performance", 1968

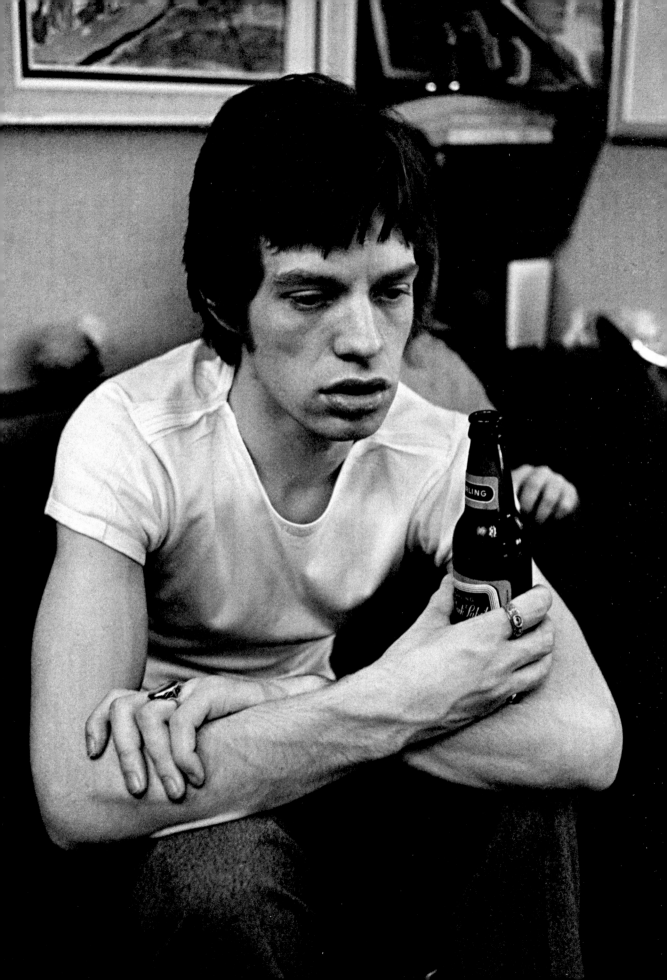

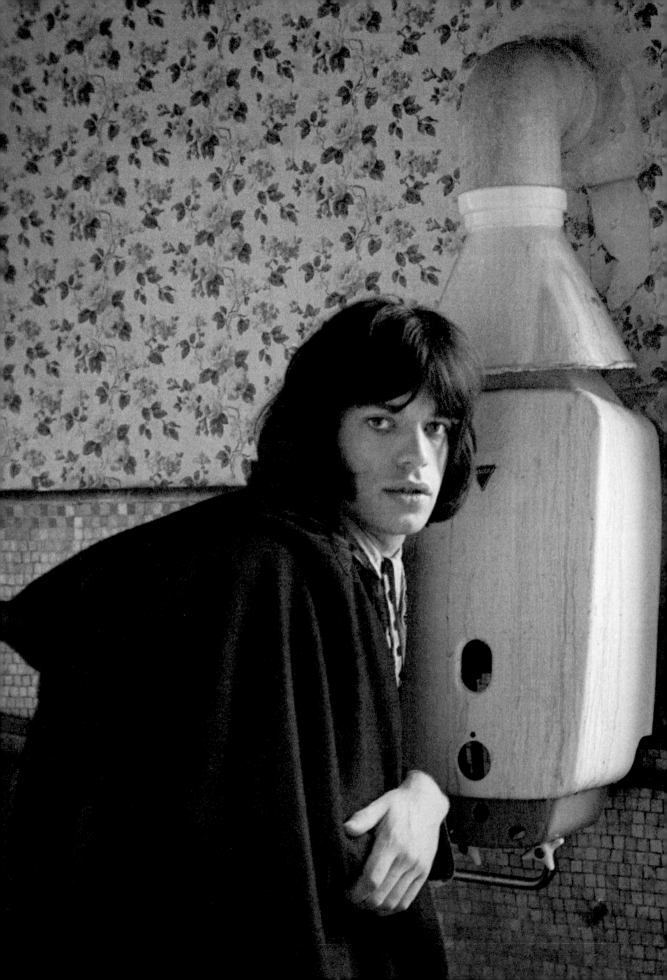

Cecil Beaton
On the set
of "Performance", 1968

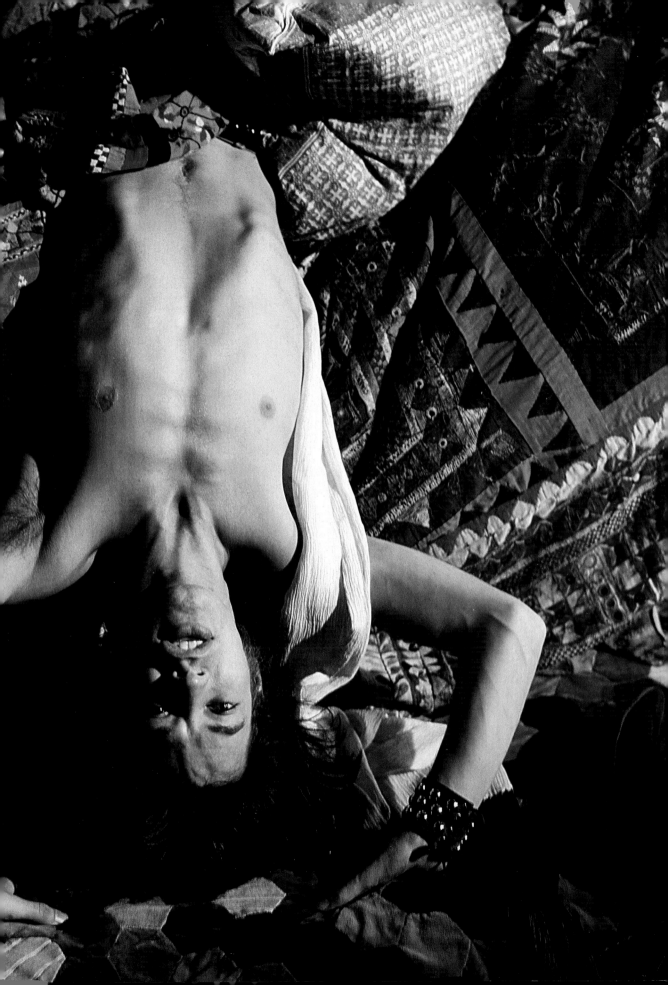

Cecil Beaton
On the set
of "Performance", 1968

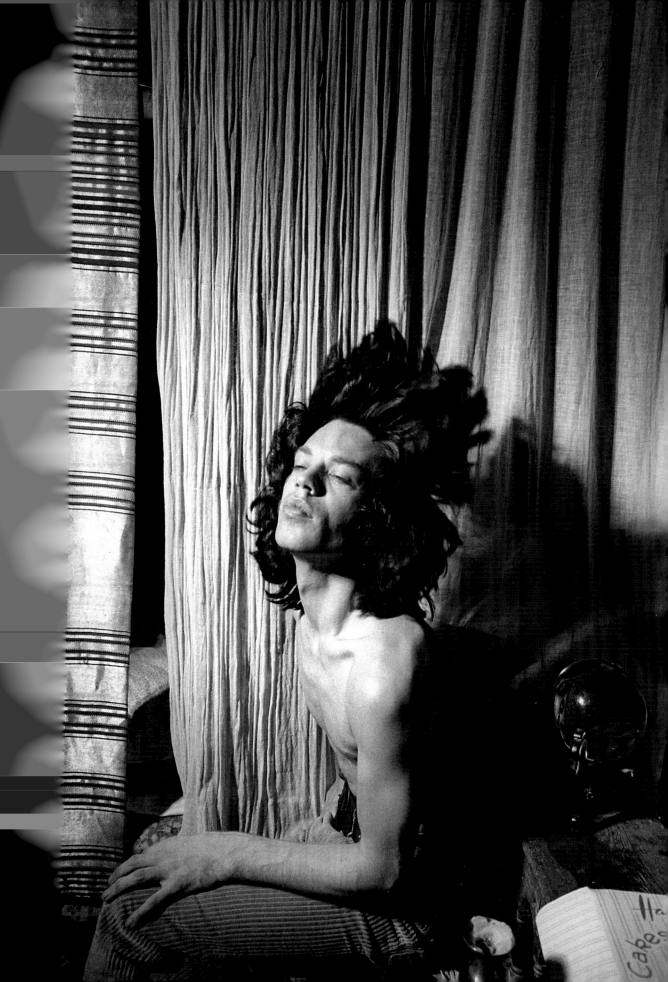

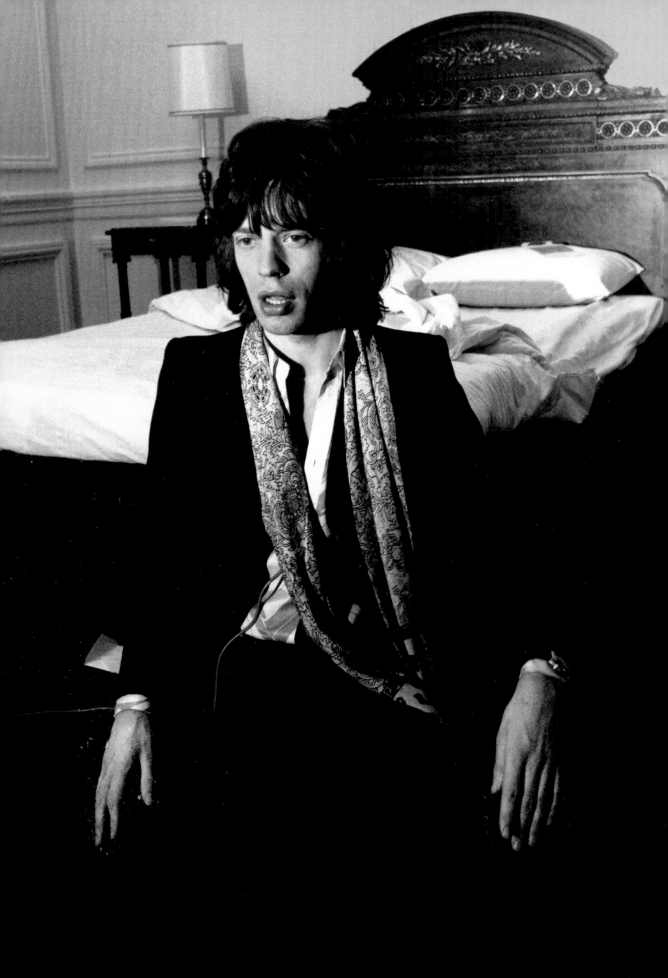

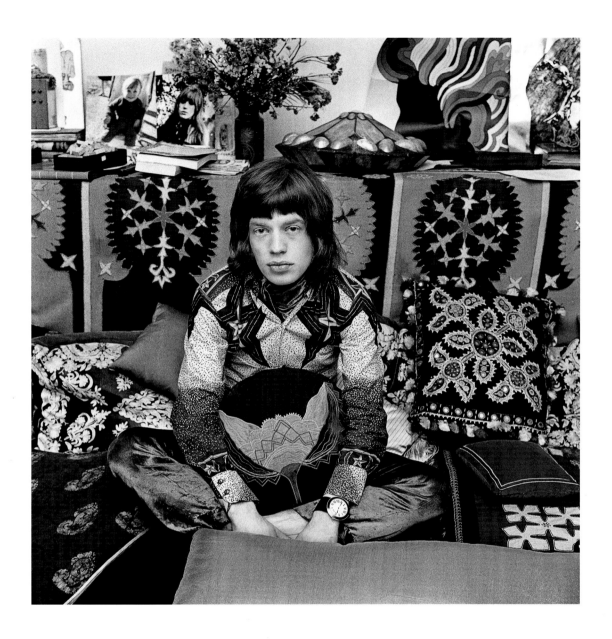

Gered Mankowitz
1968

———————————

Tony Frank
1968

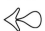

Cecil Beaton
November 1969

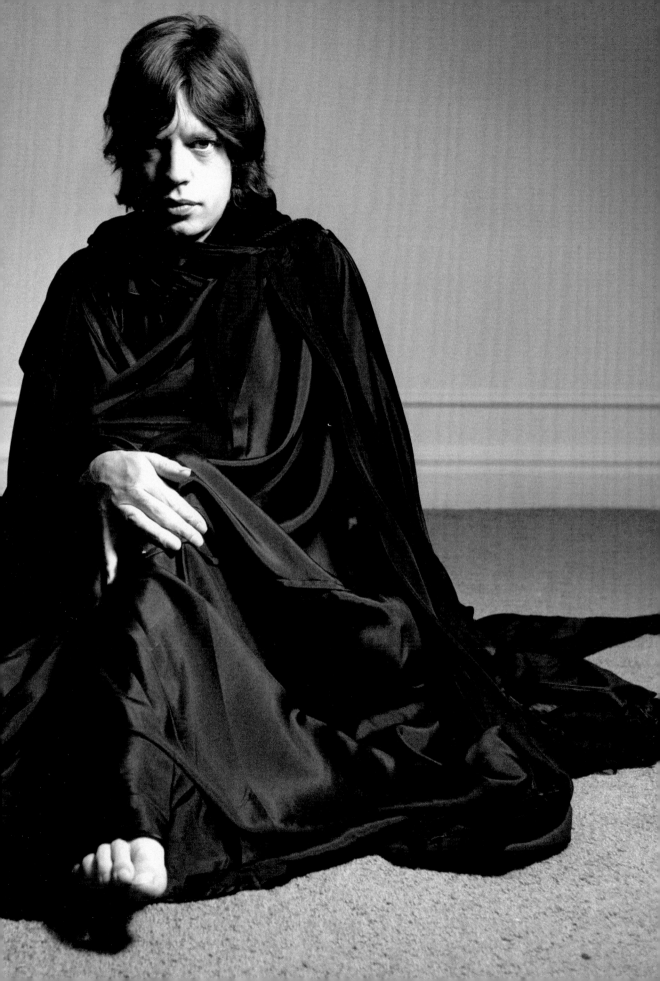

Cecil Beaton
New York, 1969

—————

Willie Christie
1969

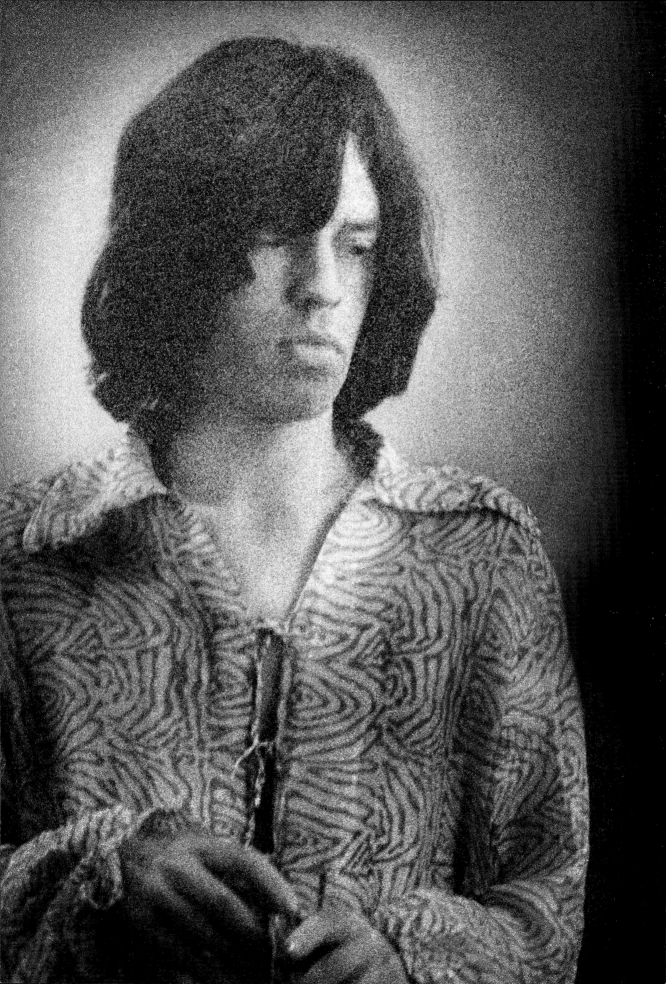

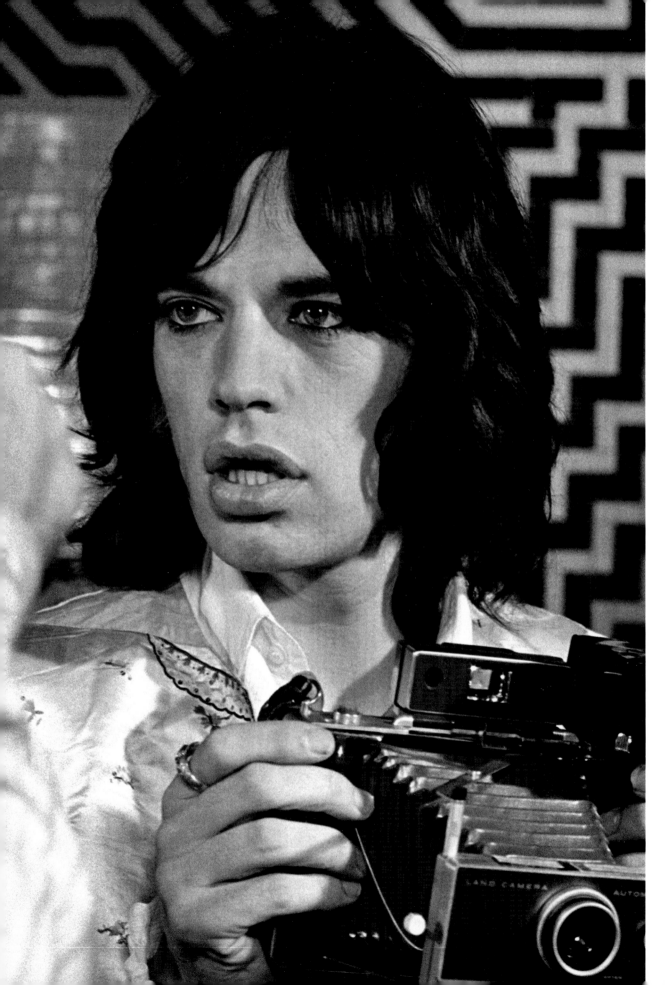

Baron Wolman
On the set of "Performance", 1969

'70

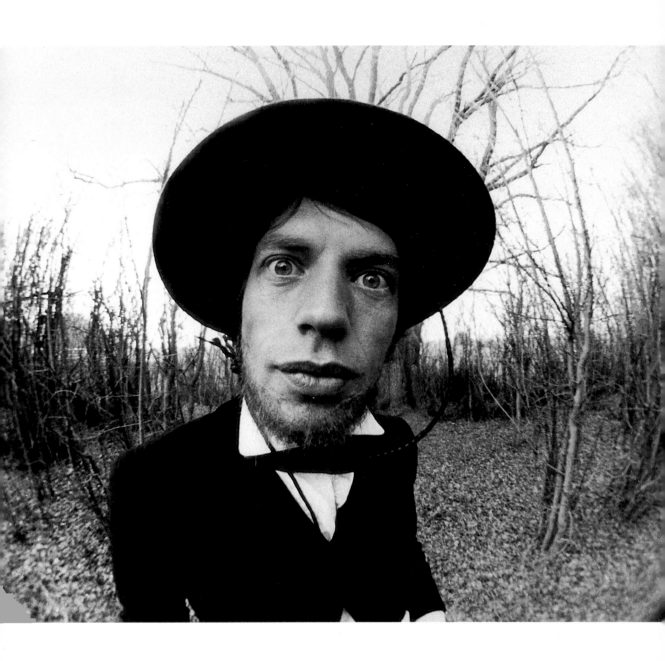

Robert Whitaker
On the set of "Ned Kelly", 1970

David Montgomery
Shoot for "Sticky Fingers", 1971

———————

Dominique Tarlé
Villa Nellcôte, 1971

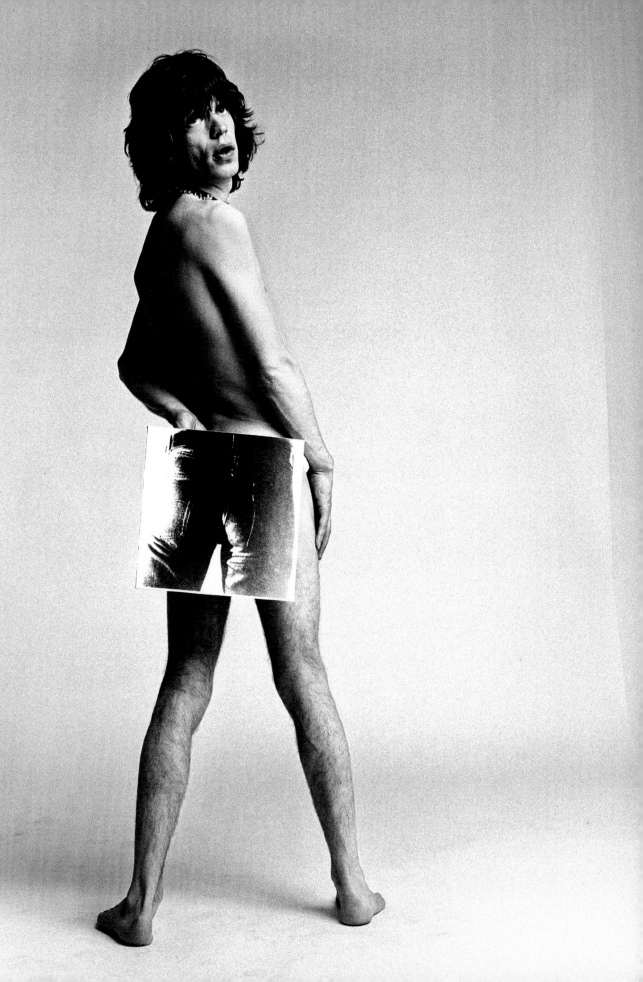

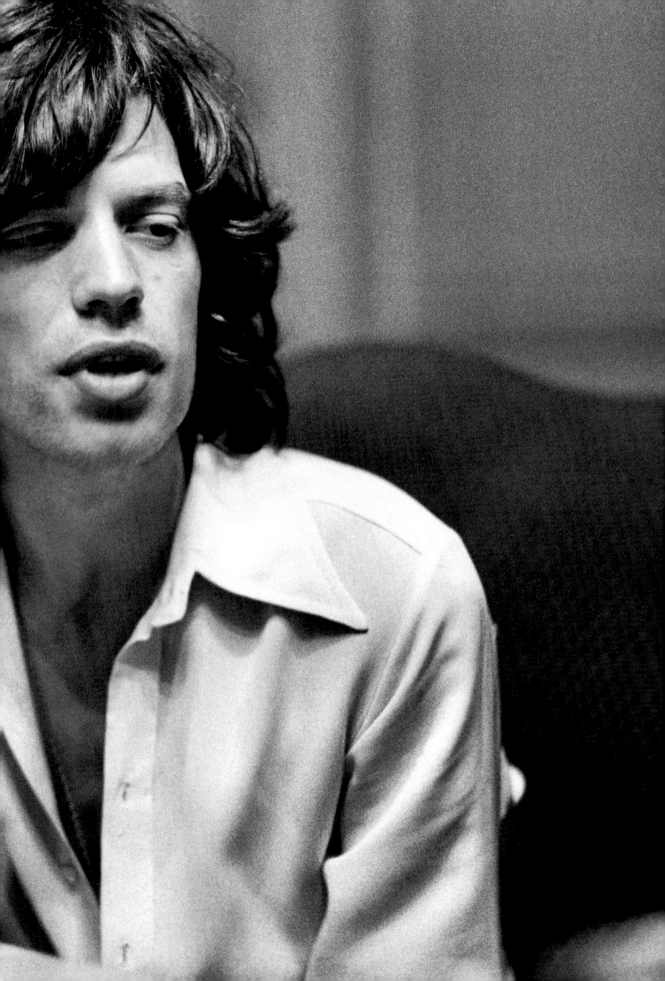

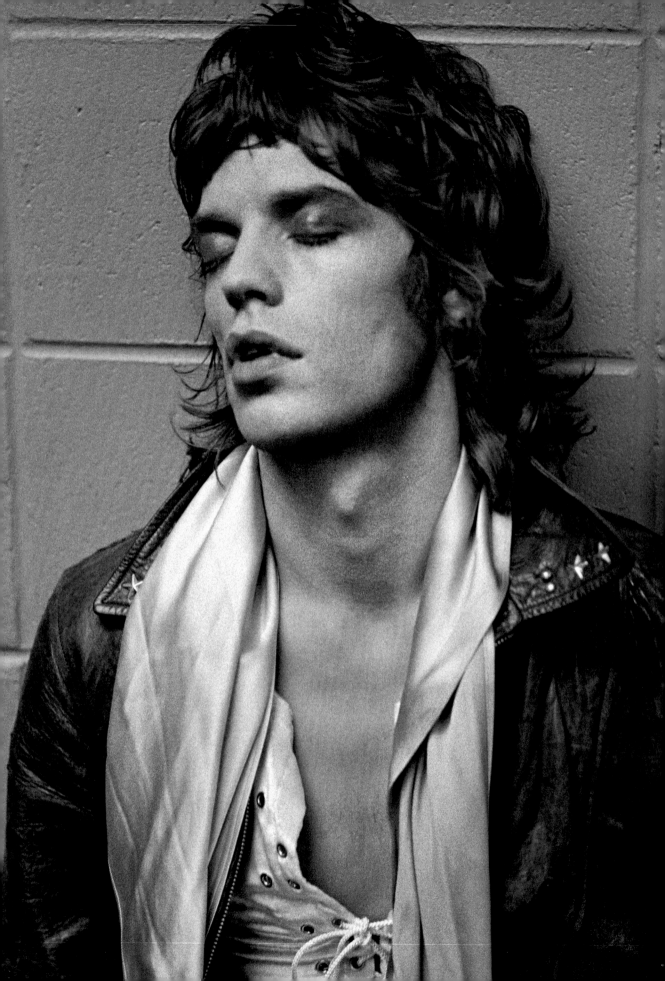

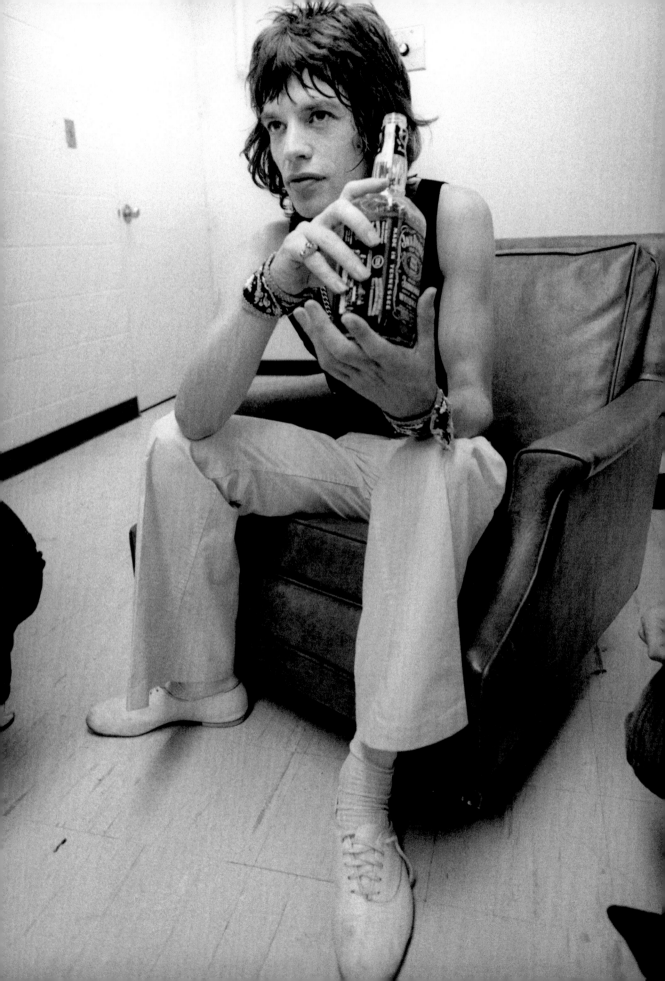

Ethan Russell
1972

———————

Jim Marshall
1972

———————

Francesco Scavullo
1972

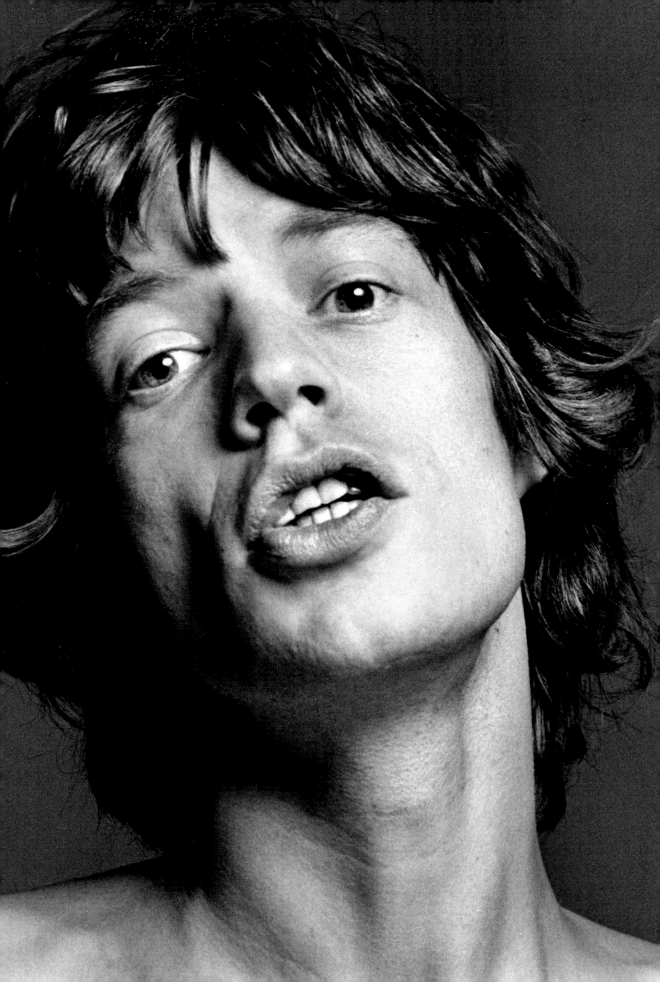

Norman Seeff
1972

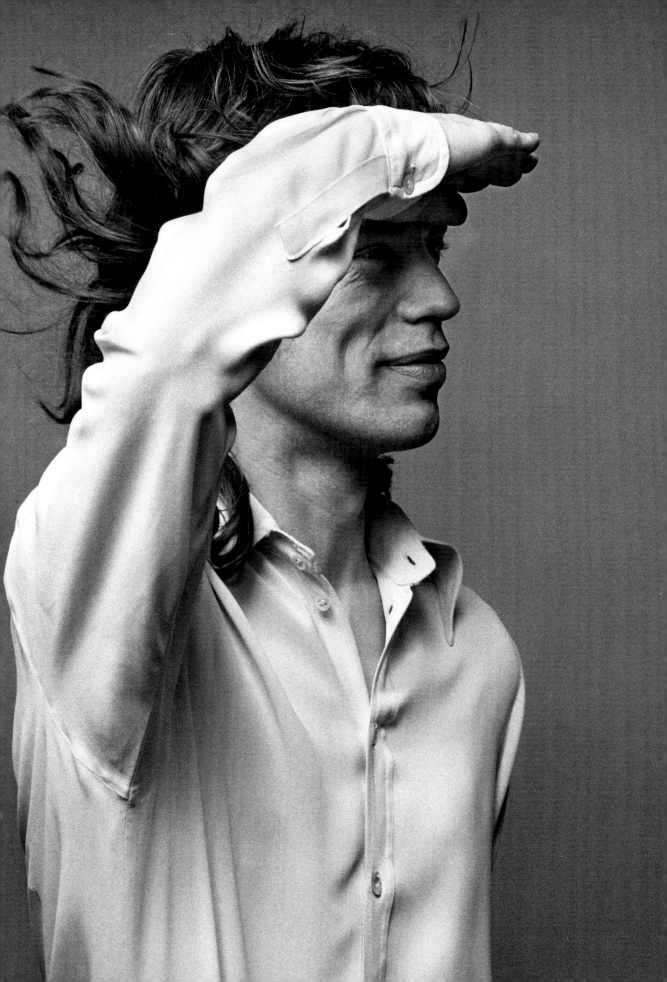

Anwar Hussein
1973

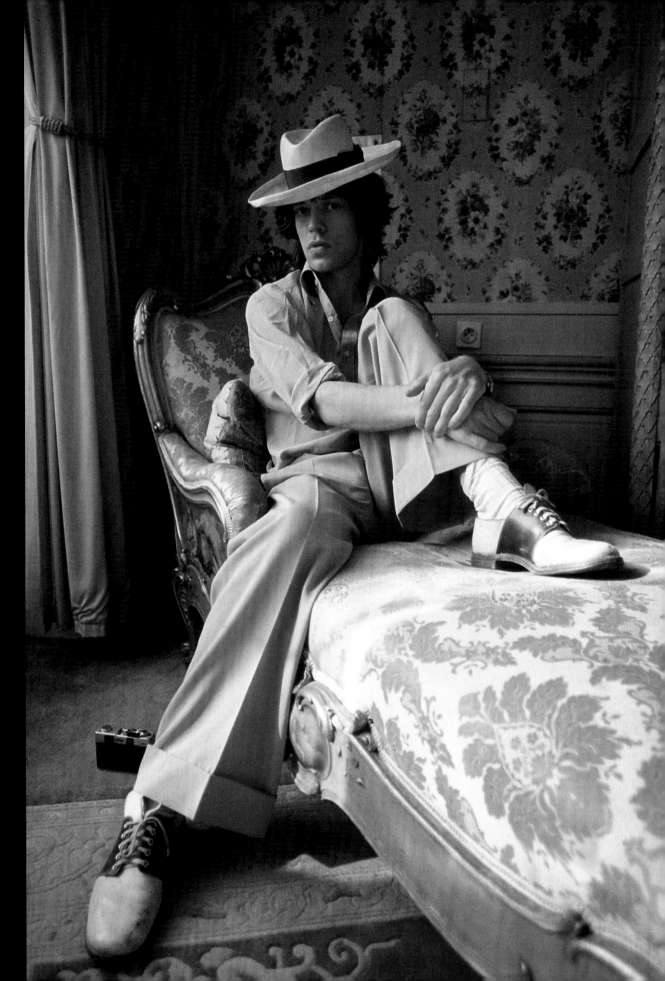

Michael Putland
1973

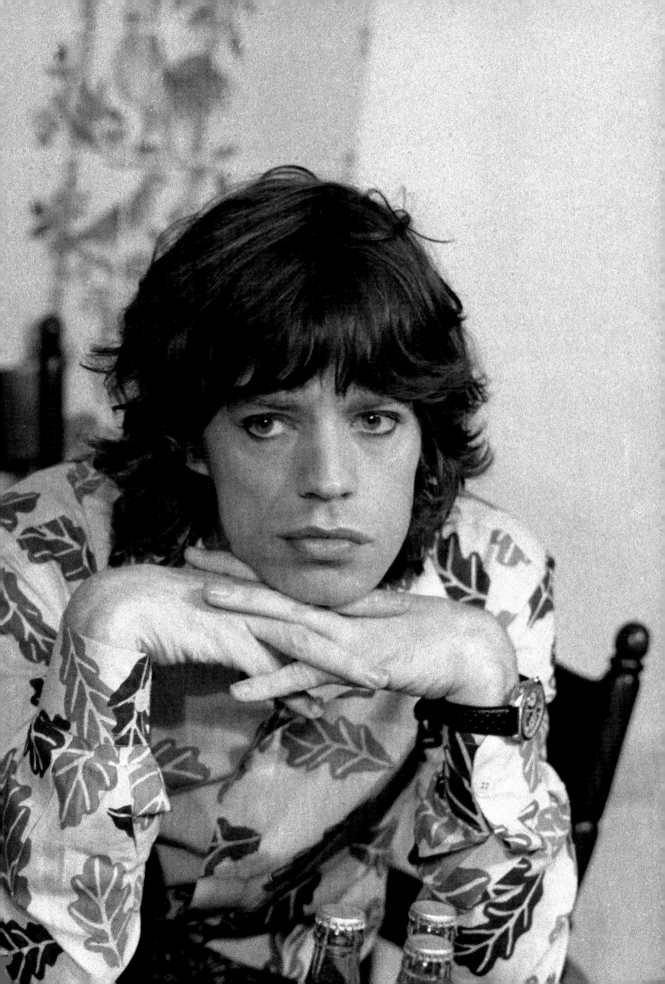

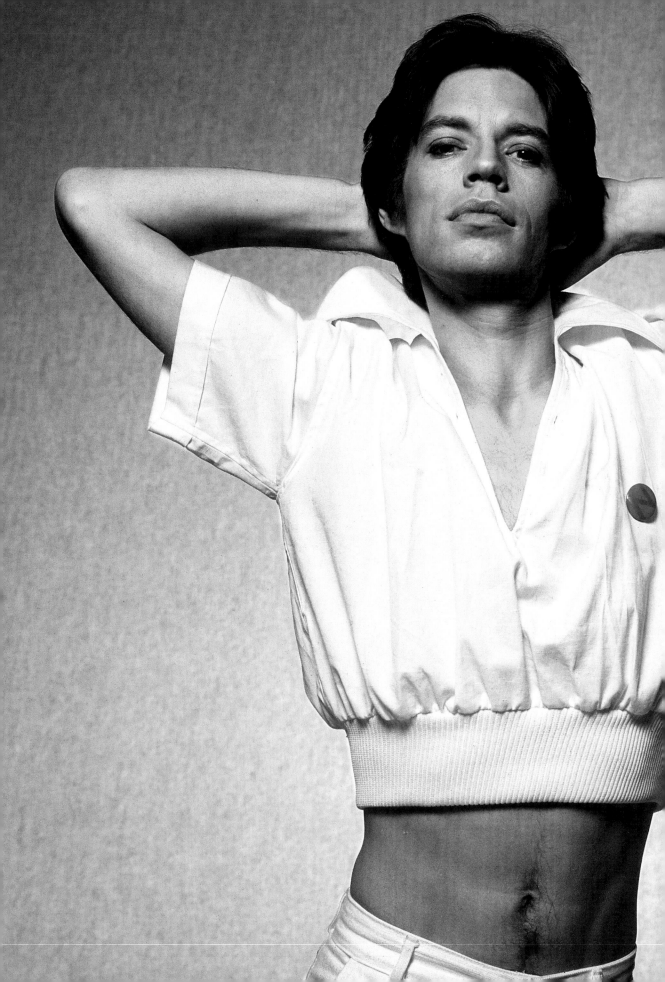

Terry O'Neill
1974

Annie Leibovitz
Buffalo, New York, 1975

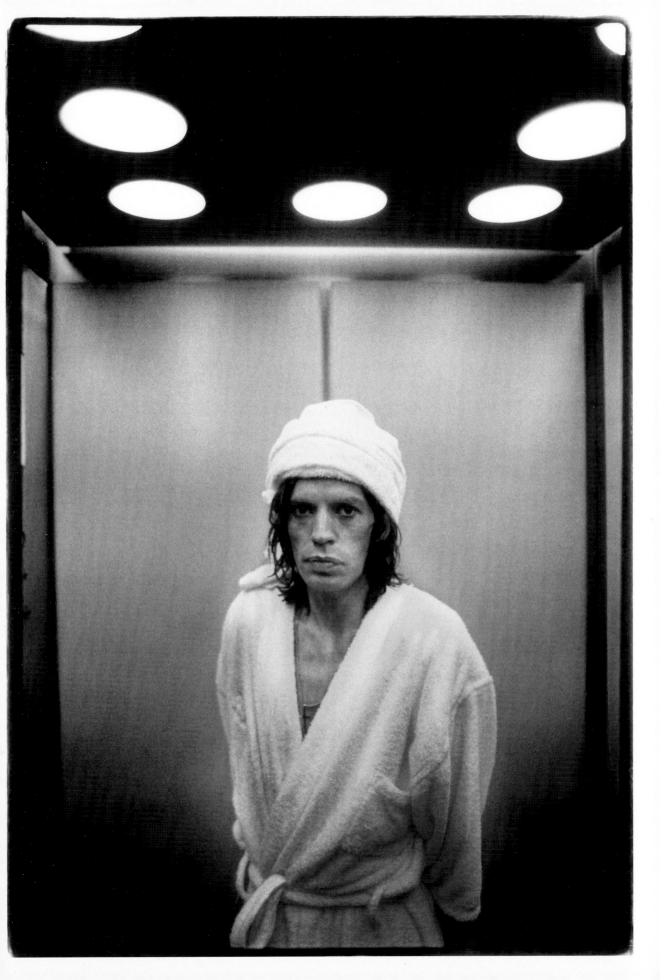

Guy Peellaert
Then there was only one, all alone.
From *Rock Dreams*, 1974

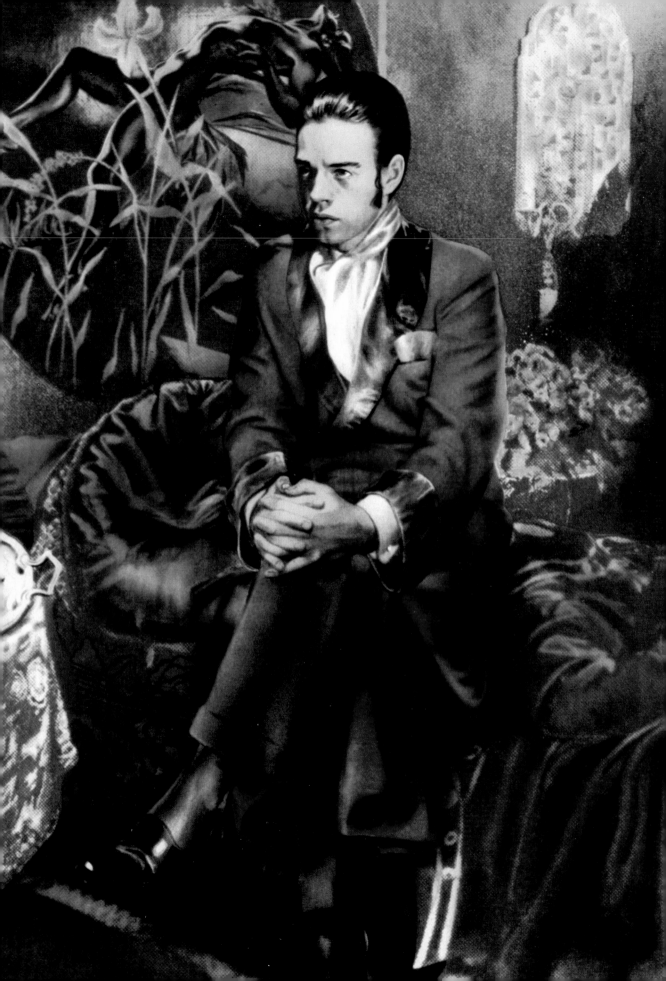

Annie Leibovitz
Southampton, New York, 1975

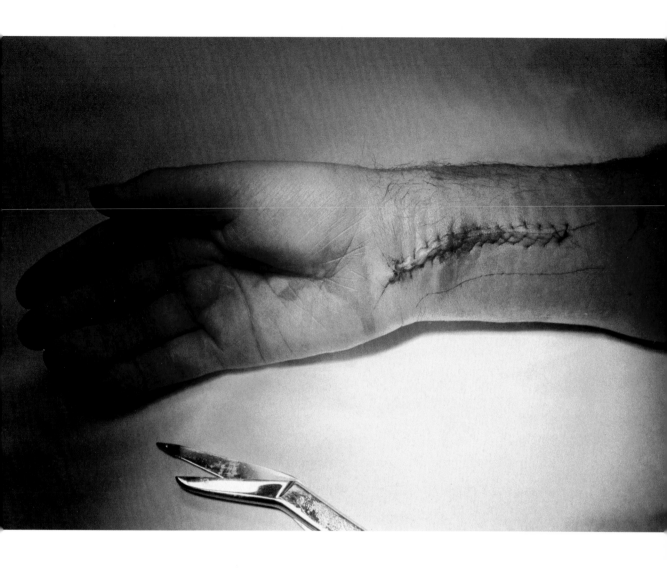

Jean-Marie Périer
1973

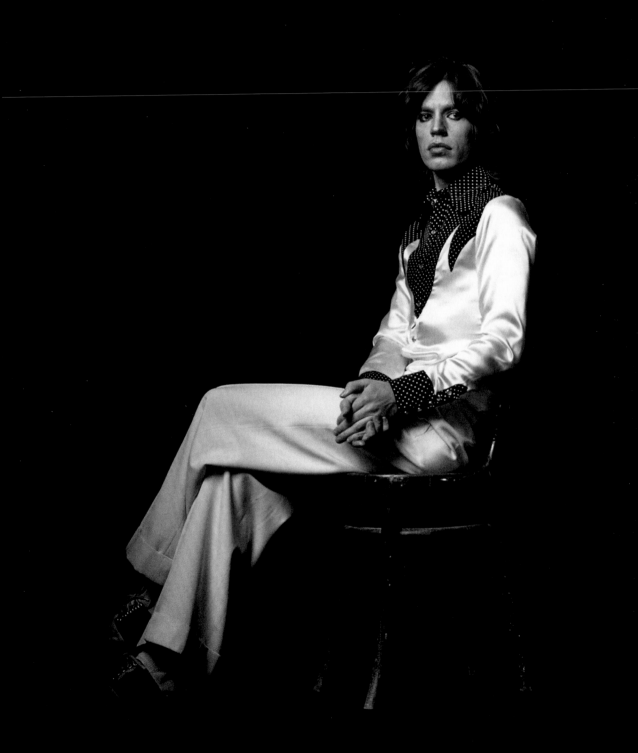

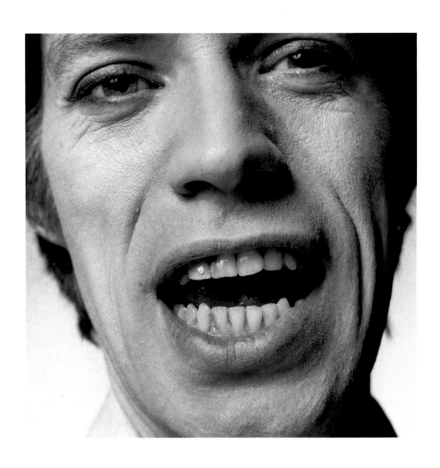

Terry O'Neill
1976

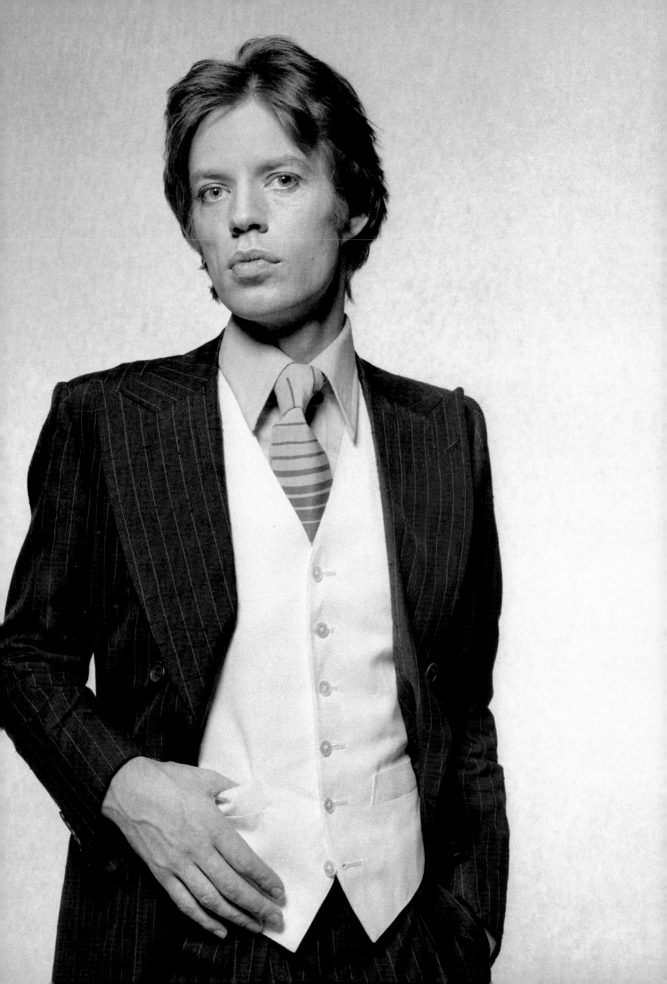

Ken Regan
1977

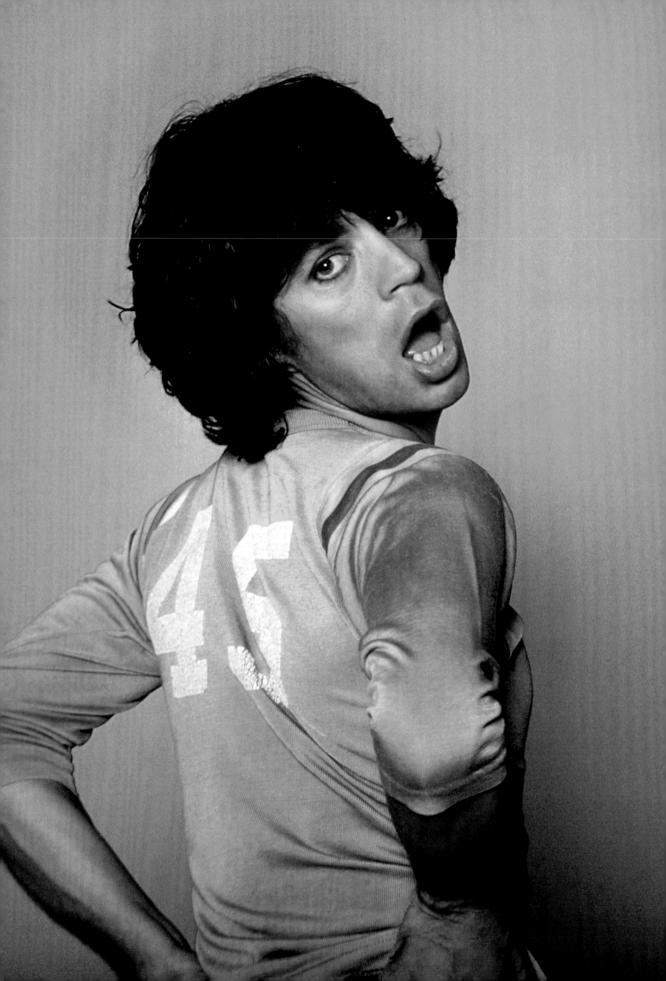

Andy Warhol
1975

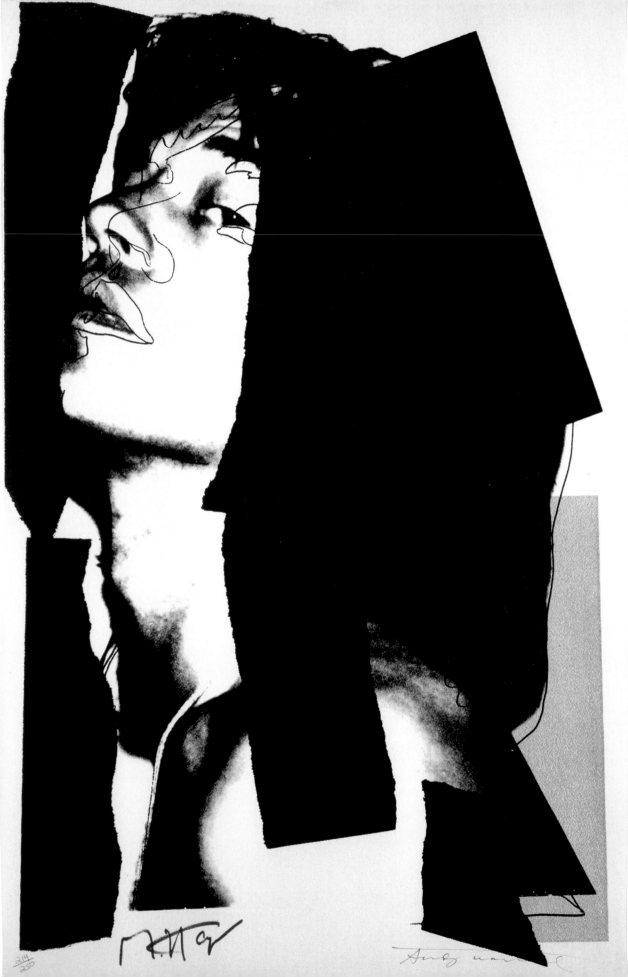

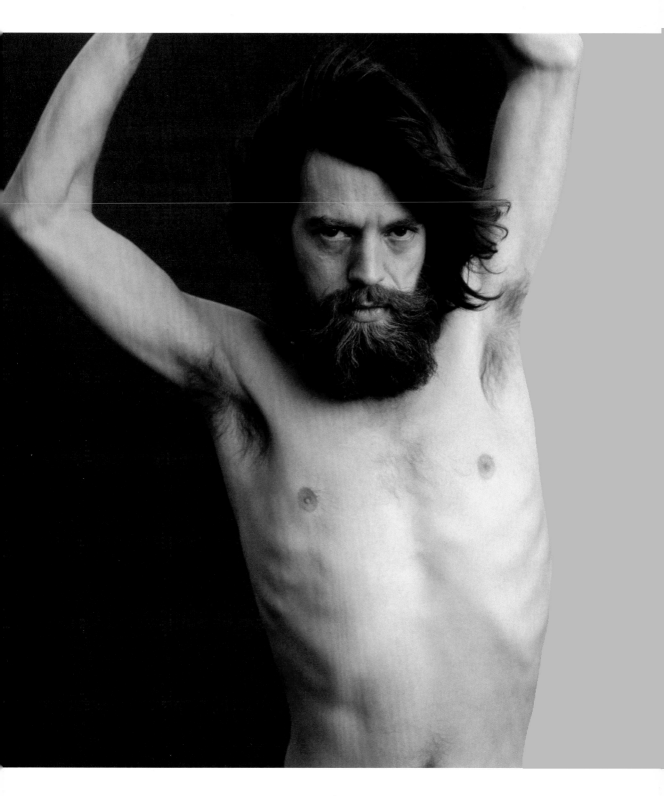

Annie Leibovitz
New York, 1980

Claude Gassian
Paris, 1985

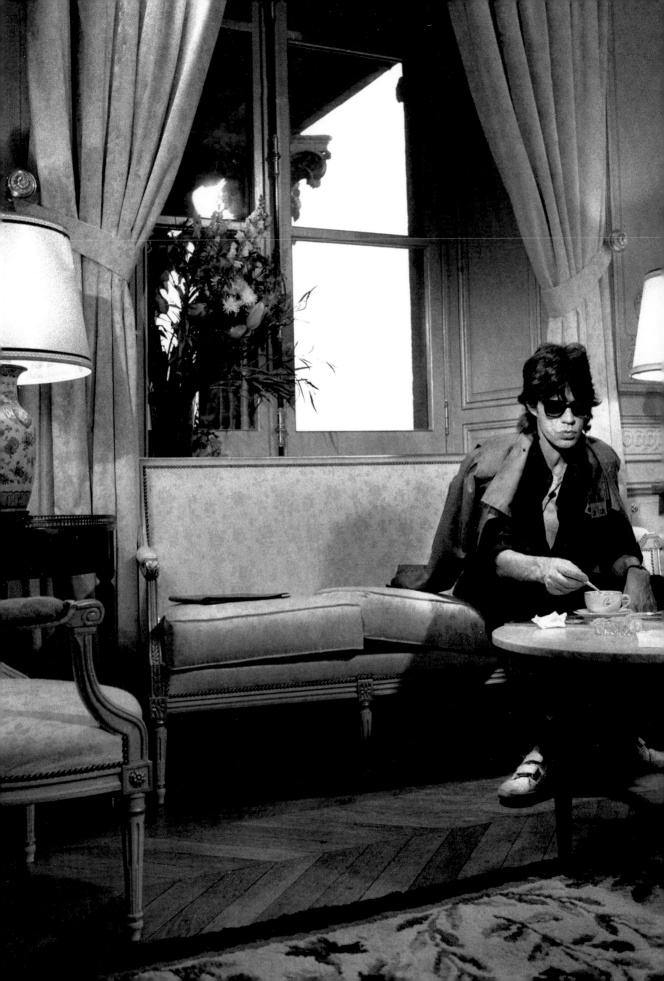

Herb Ritts
London, 1987

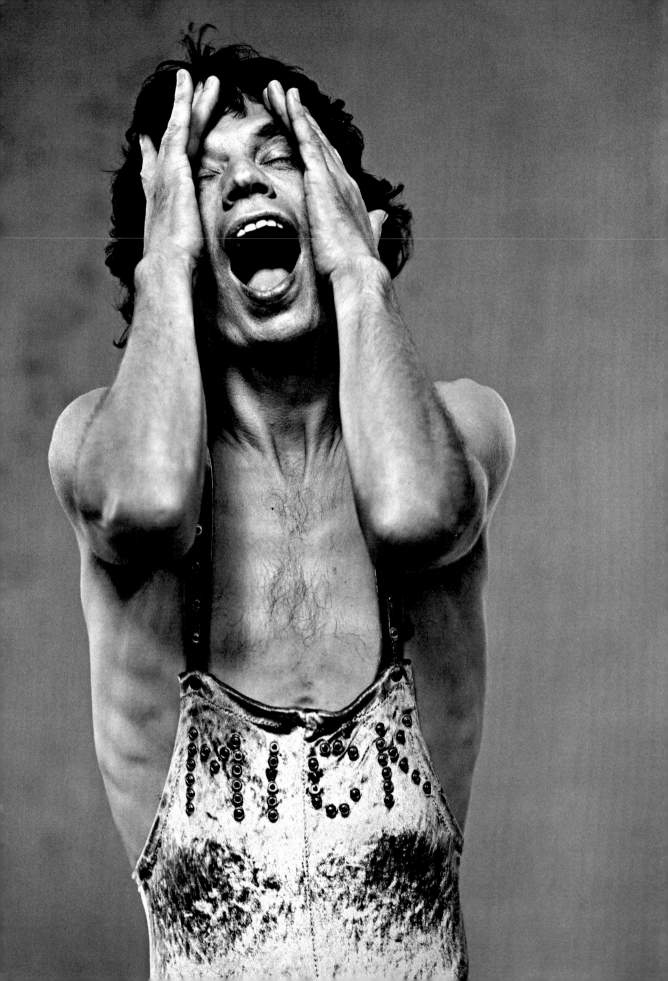

Pierre Terrasson
London, 1987

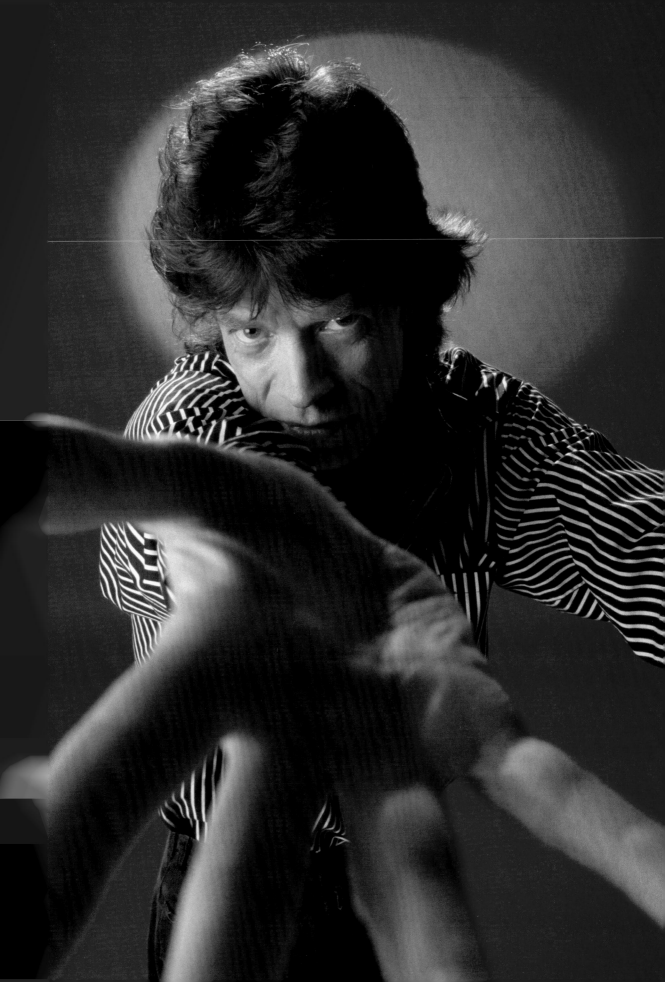

Deborah Feingold
1987

Enrique Badulescu
1989

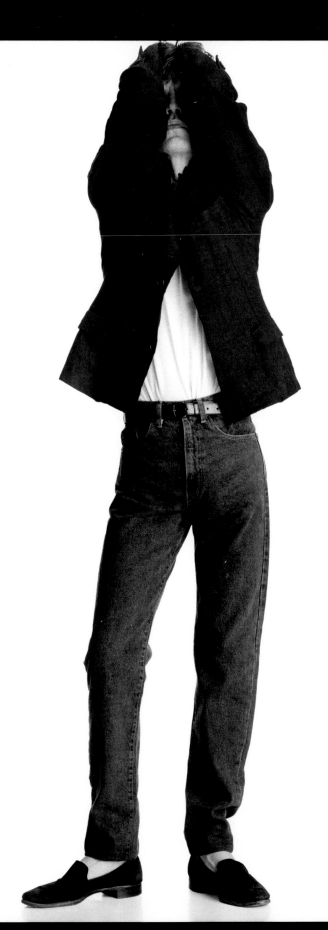

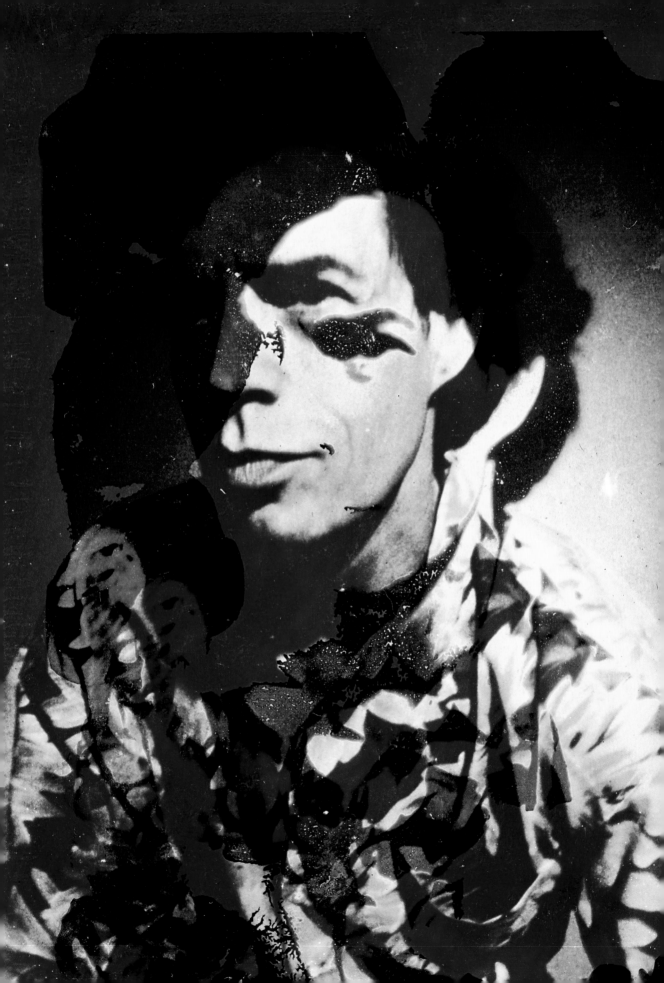

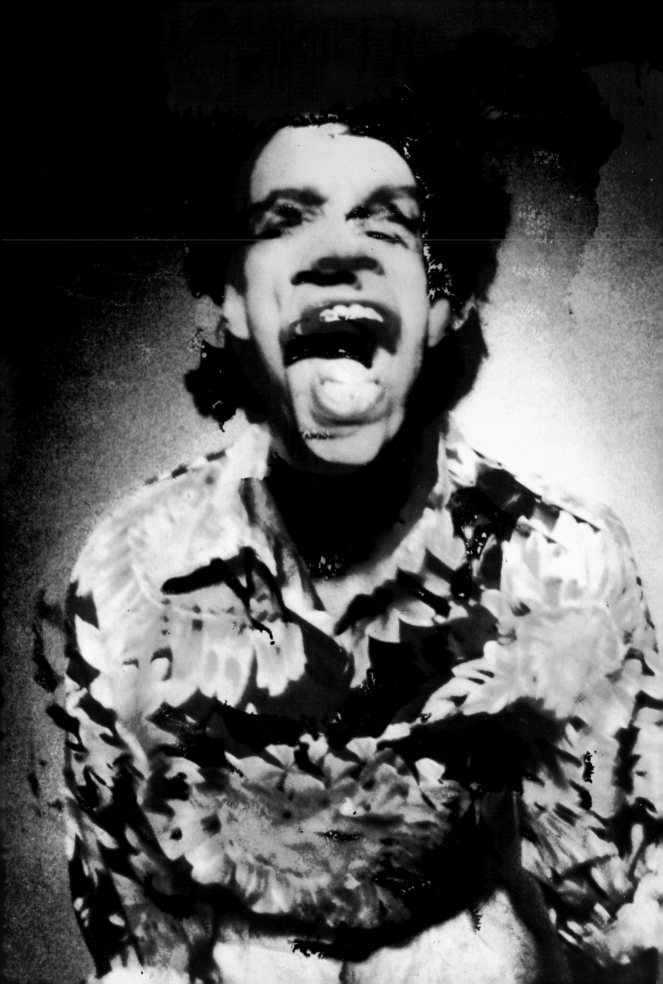

Enrique Badulescu
1989

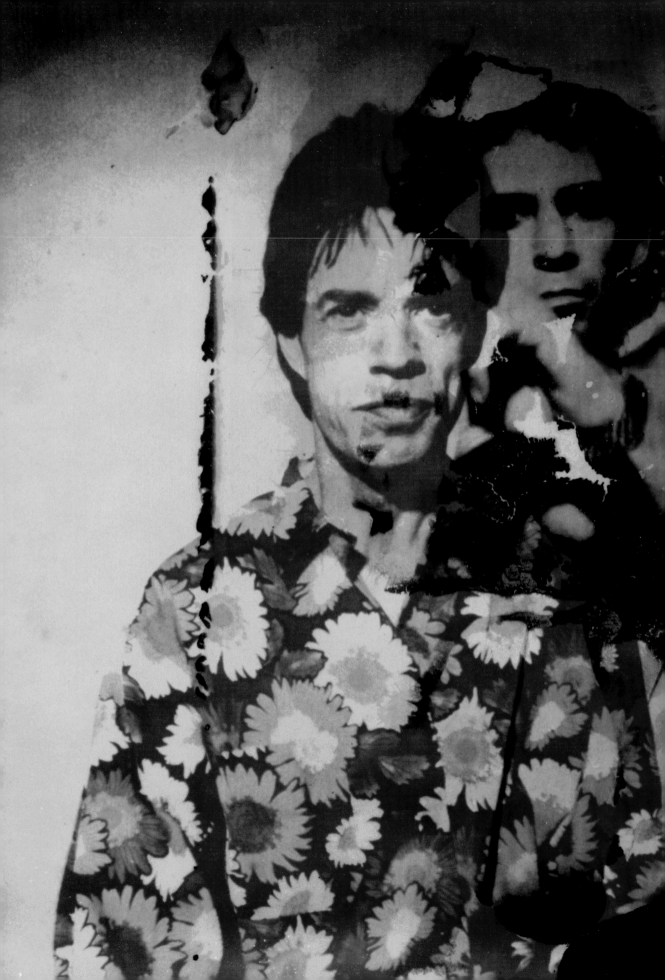

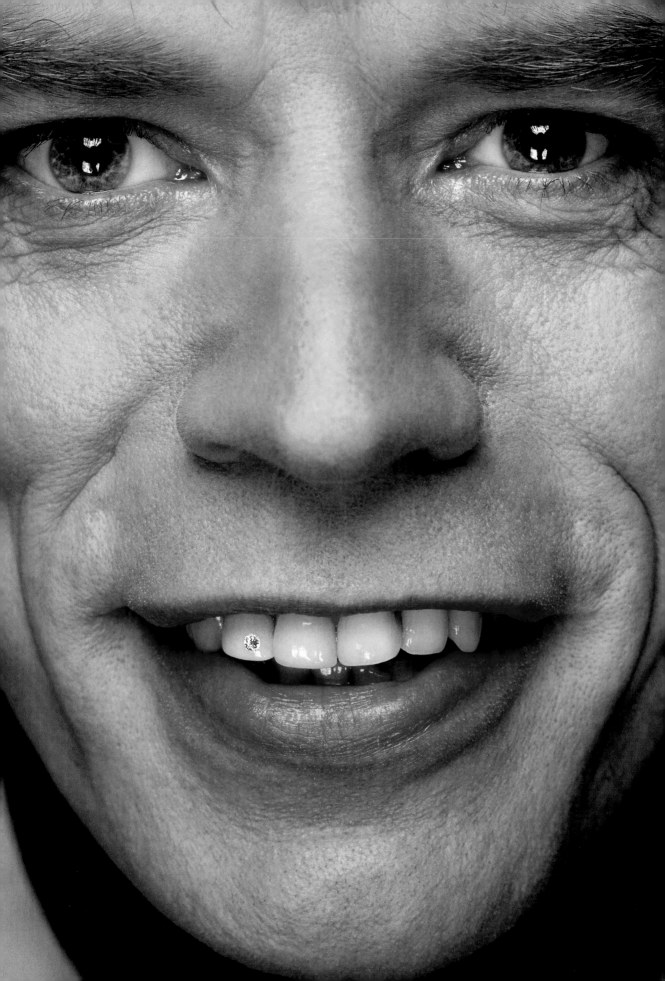

Brian Aris
1992

Terry O'Neill
1990

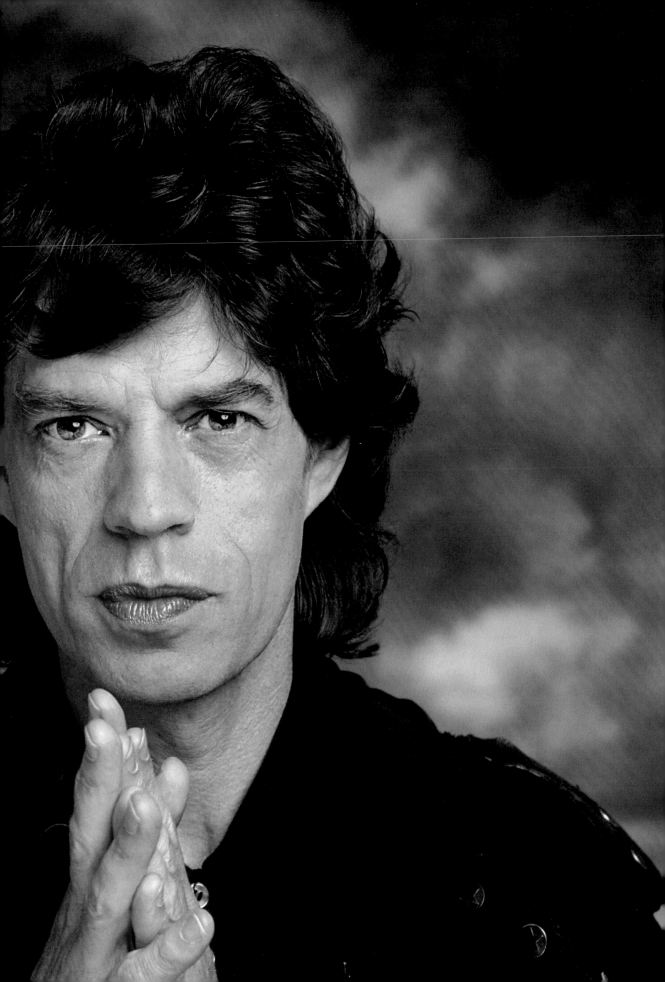

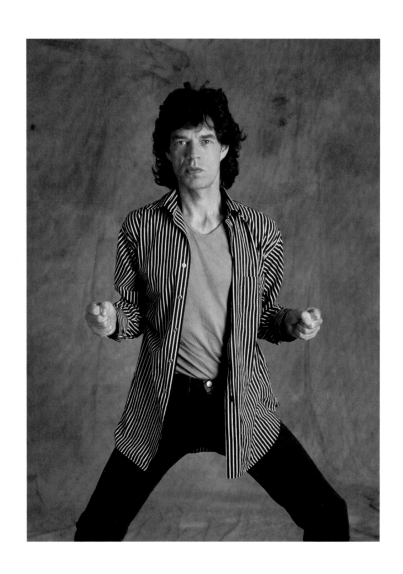

Michael Putland
1990

Kevin Cummins
1990

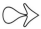

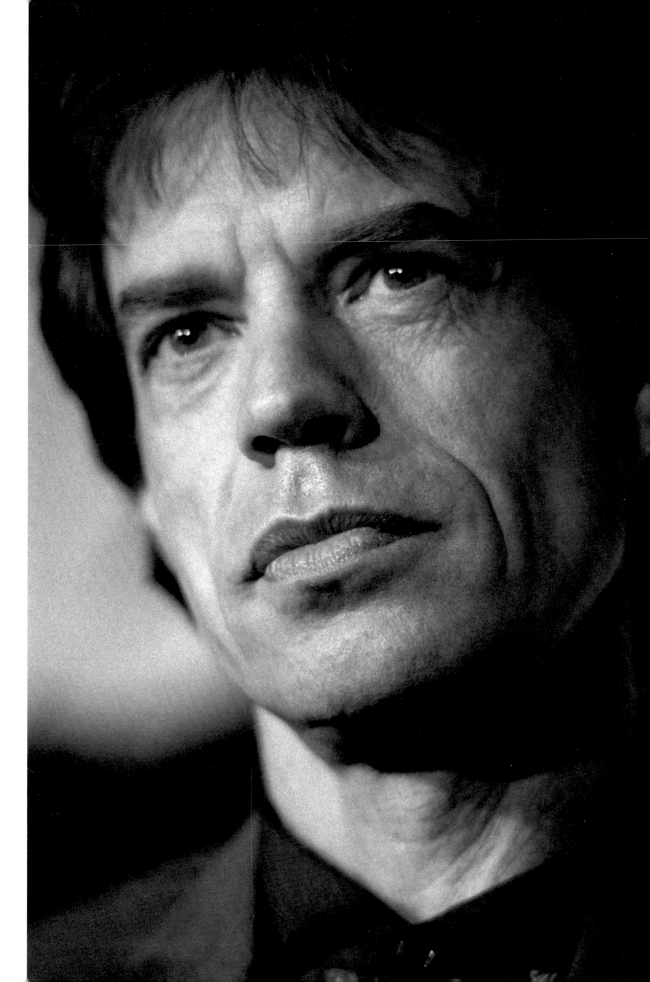

Brian Aris
1992

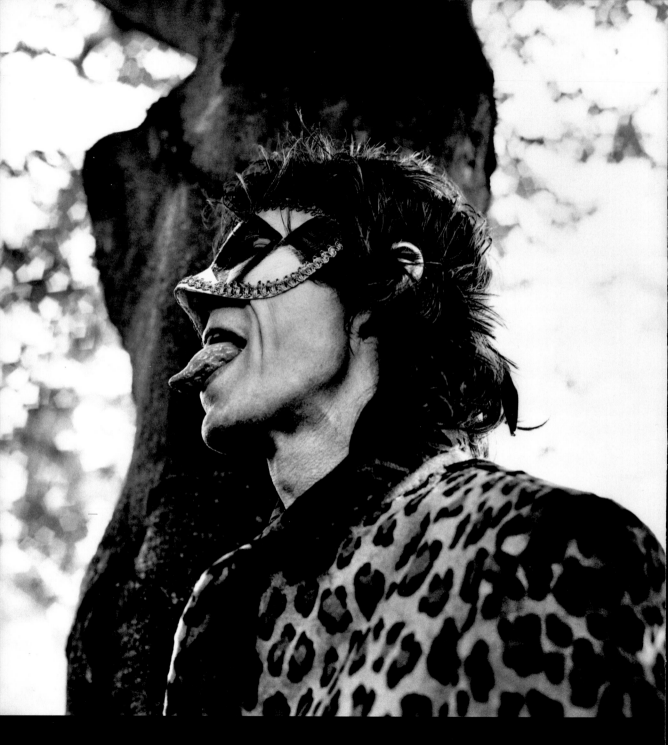

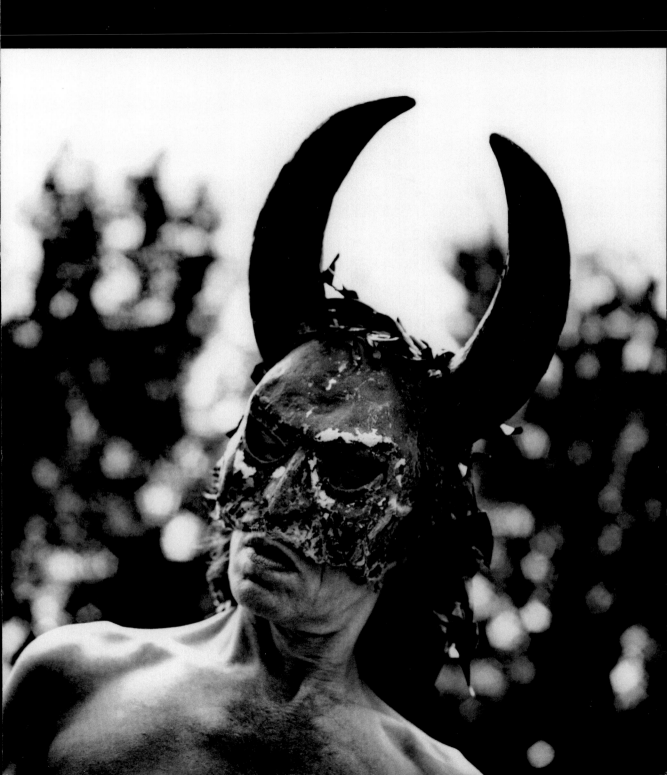

Sante D'Orazio
West Village, New York City, 1994

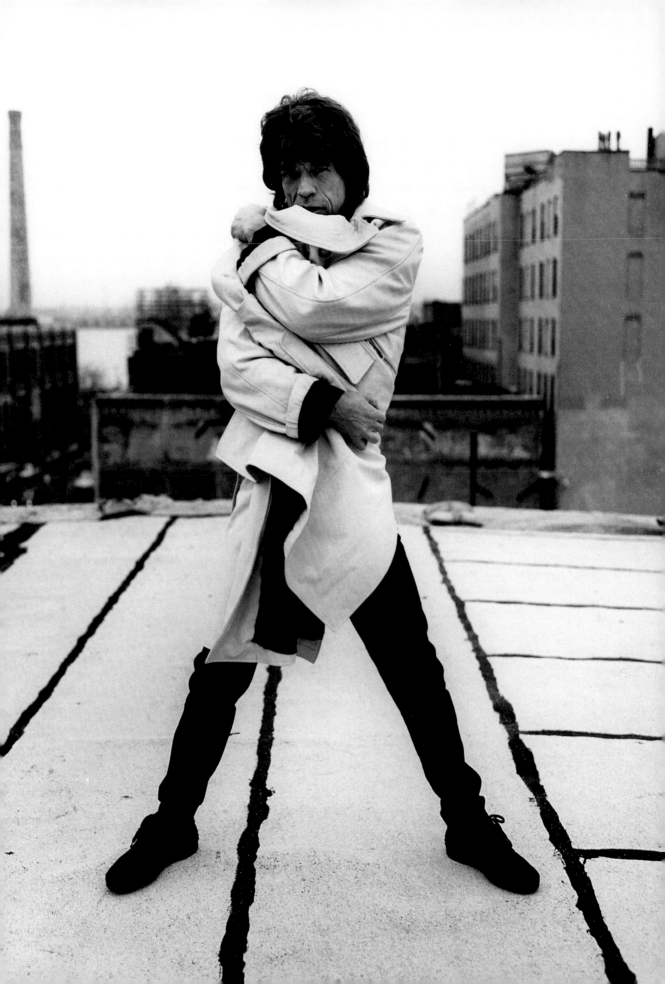

Annie Leibovitz
Los Angeles, 1992

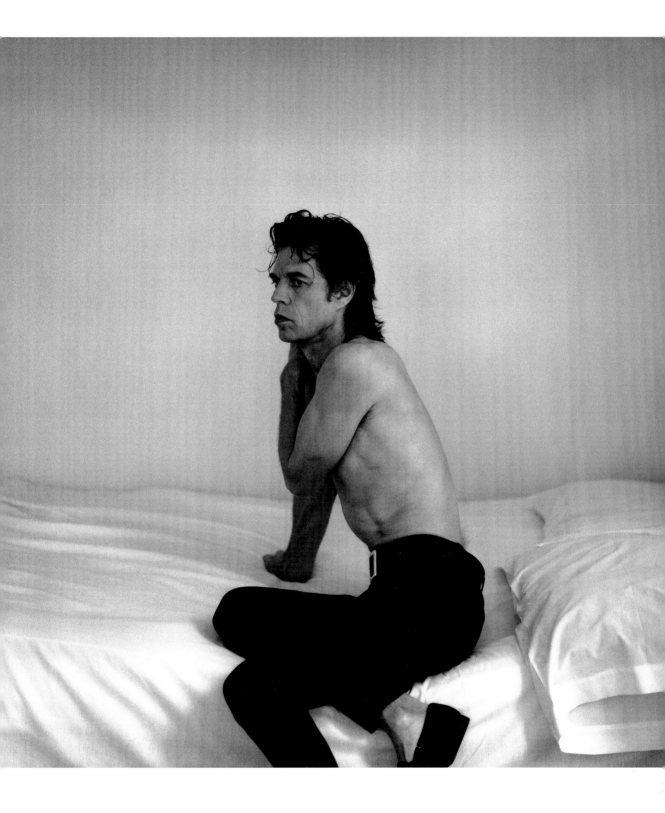

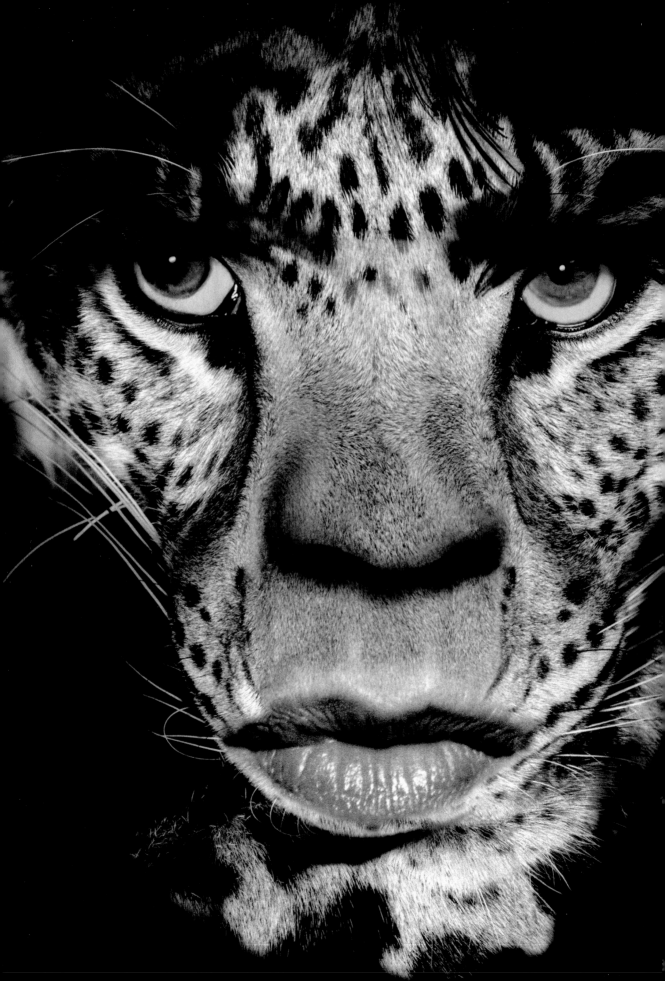

Albert Watson
Los Angeles, 1992

Sante D'Orazio
West Village, New York City, 1994

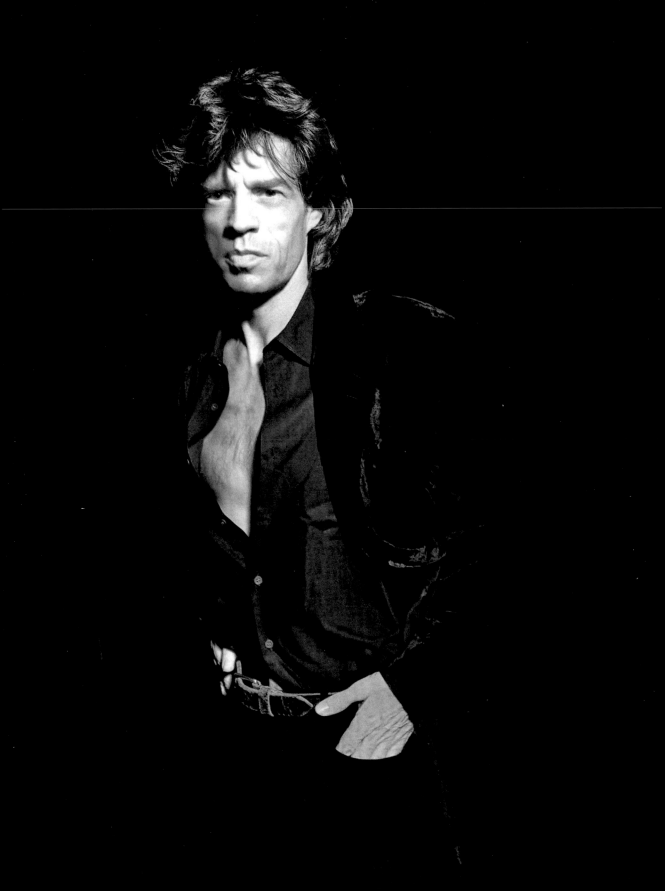

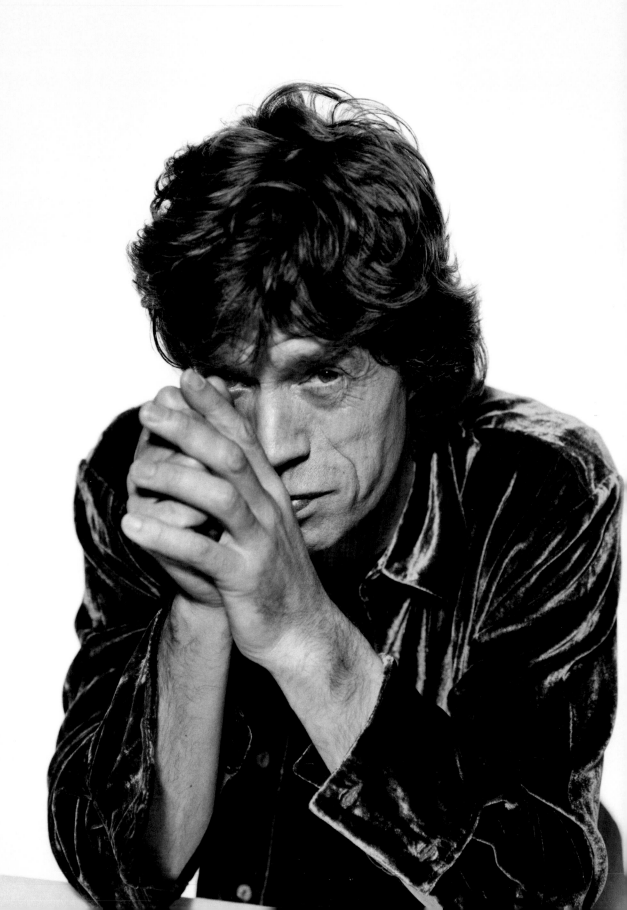

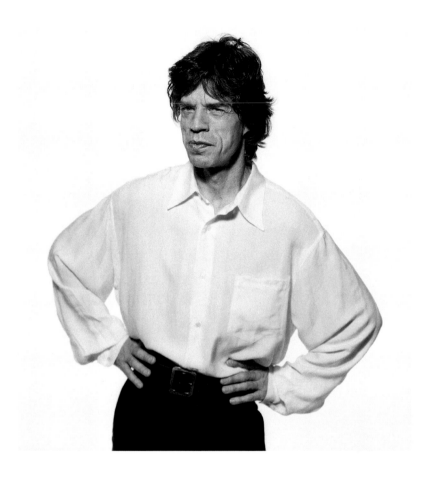

Peter Lindbergh
Rolling Stone magazine, London 1995

Anton Corbijn
Toronto, 1994

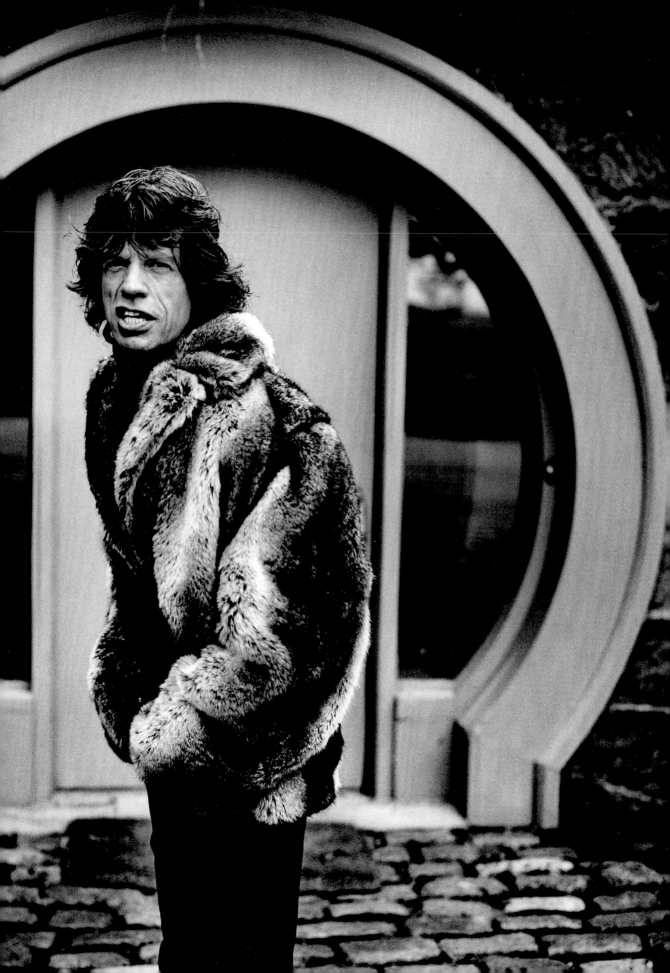

Claude Gassian
Copenhagen, 1995

Claude Gassian
Copenhagen, 1995

———————

Mark Seliger
1994

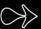

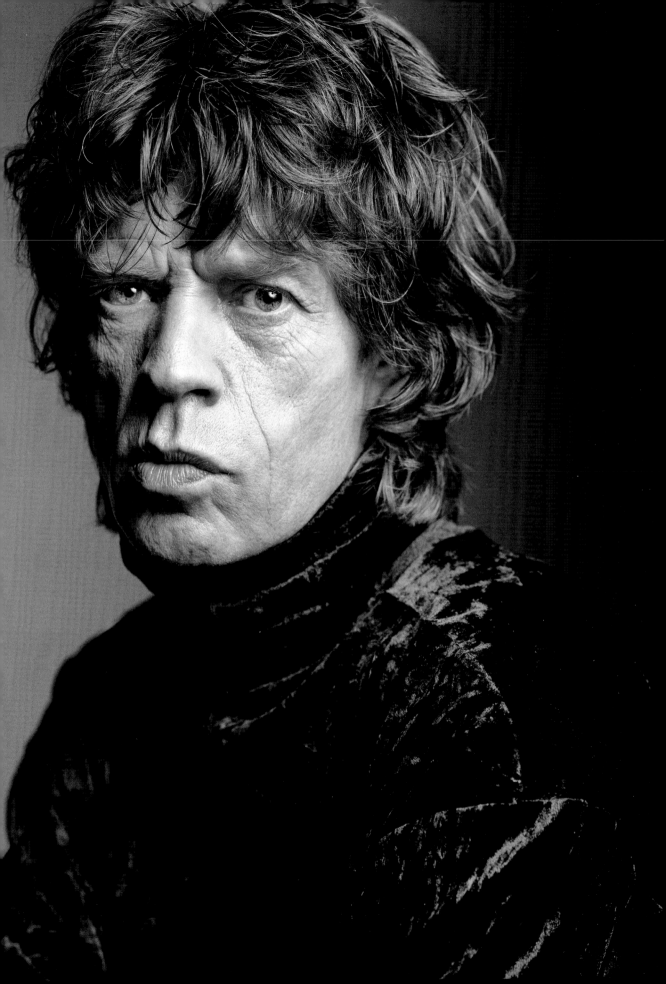

Annie Leibovitz
Album cover. Los Angeles, 1992

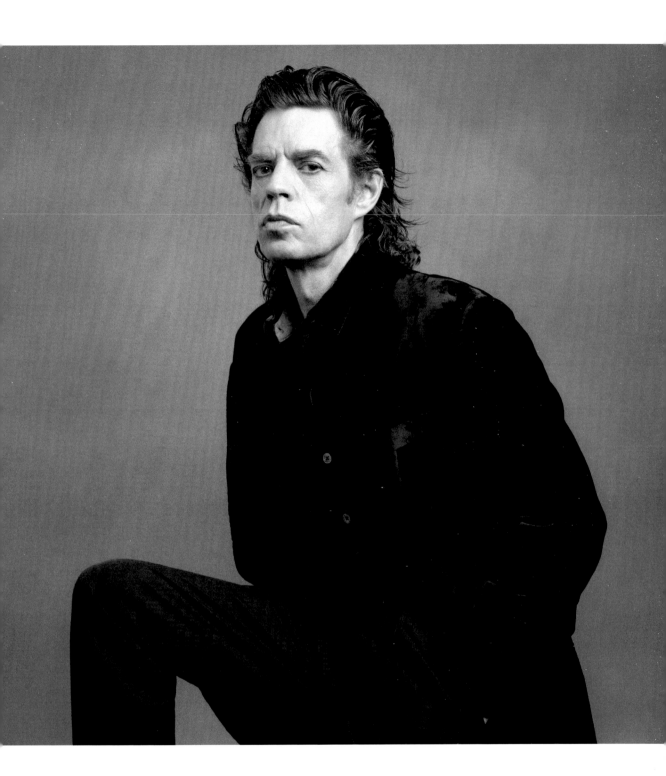

Anton Corbijn
Still for the movie "Bent",
Glasgow, 1996

Anton Corbijn
Still for the movie "Bent",
Glasgow, 1996

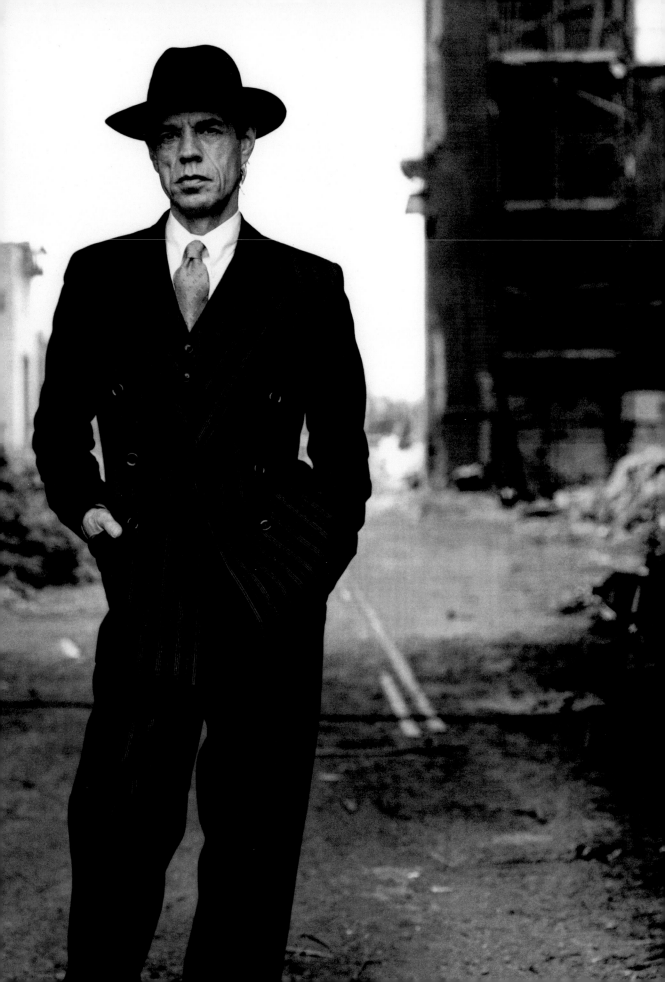

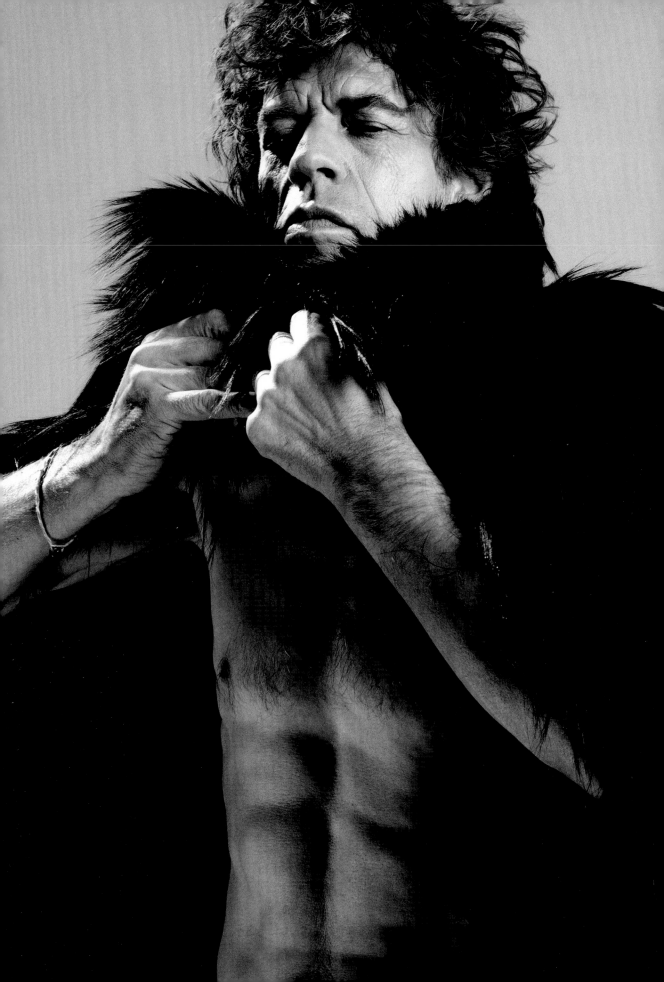

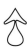

Karl Lagerfeld
2001

———————

Karl Lagerfeld
2001

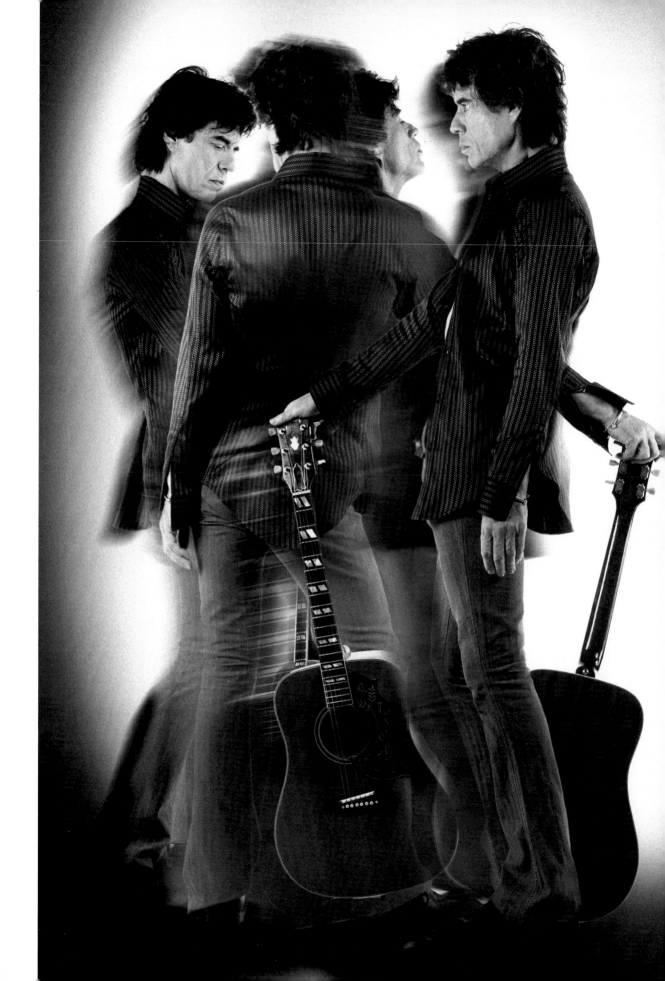

Mark Seliger
2005

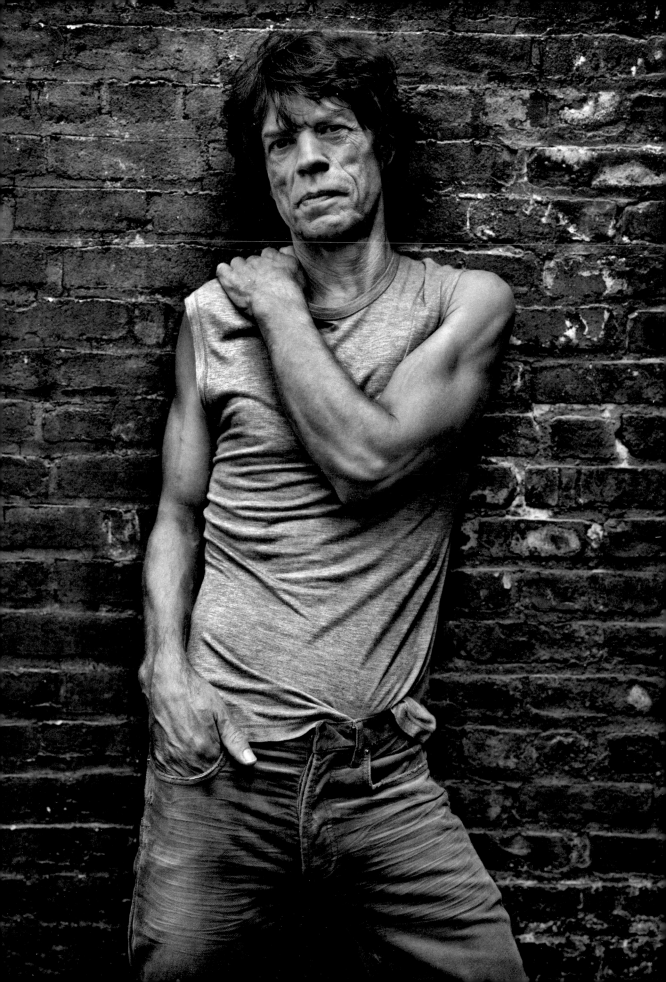

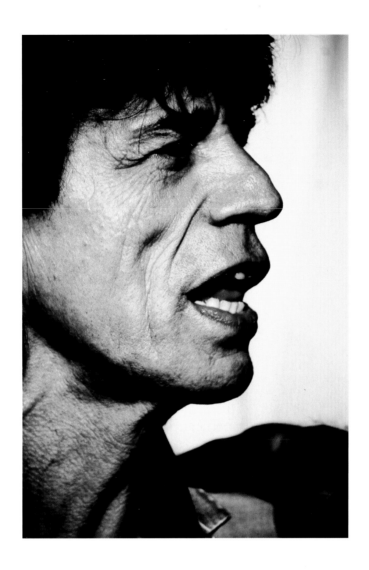

Simone Cecchetti
2007

———————

Karl Lagerfeld
2001

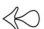

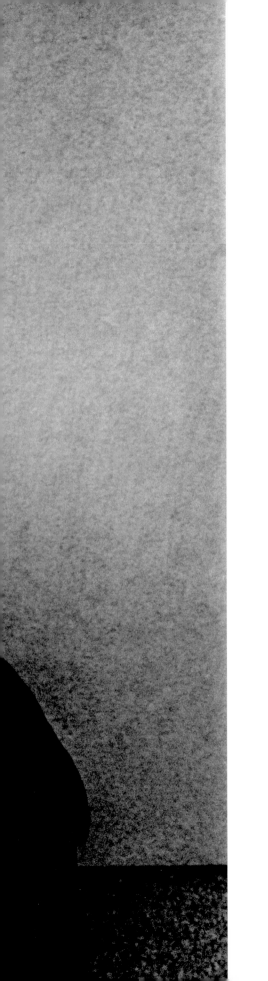

Anton Corbijn
Shoot for Rolling Stone magazine,
Toronto, 2005

Bryan Adams
2008

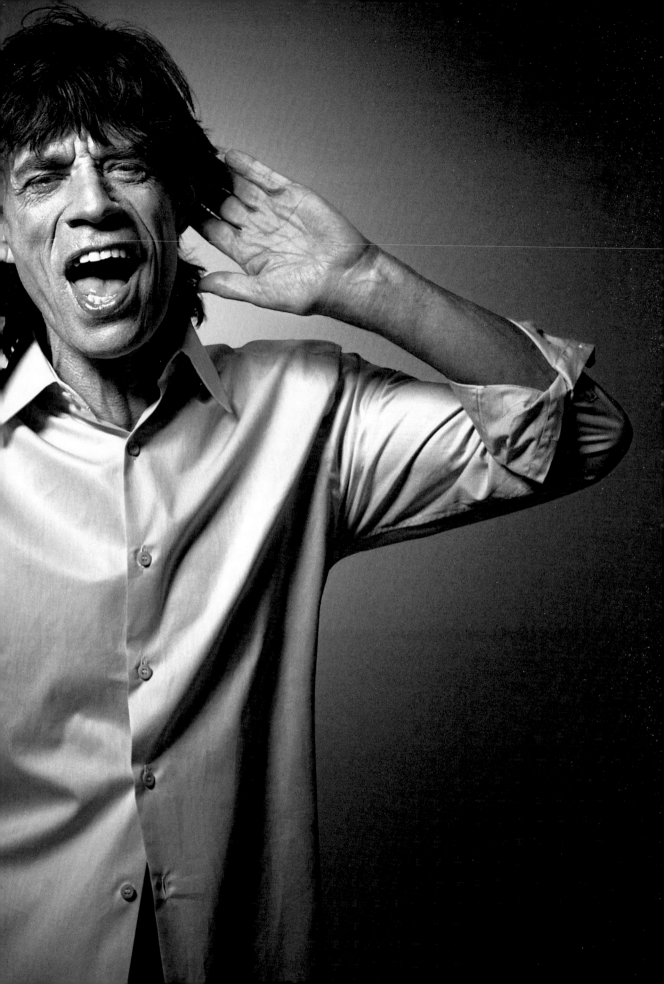

ABOUT THE IMAGES

1960s

Harry Goodwin (*UK, born 1924*)
From 1963 to 1973, Goodwin was the resident photographer on *Top of the Pops*, the popular BBC TV show that revolutionized the sixties music scene. Stars from all over the world passed through its studios in Manchester and London, and Goodwin built up an extraordinary gallery of portraits of the big names in rock and pop.

Gered Mankowitz (*UK, born 1946*)
Son of the author and screenwriter Wolf Mankowitz, Gered has spent forty years photographing the leading lights of rock. Marianne Faithfull introduced him to Andrew Loog Oldham, manager and producer of the Rolling Stones, who invited him to accompany the band on their 1965 US tour. This was the start of a long partnership, with Mankowitz shooting the Stones in concert, backstage, in the studio, and at home.

'I loved that coat. It was a cold autumn evening on the roof of Harley House in Marylebone, where Mick had just bought an apartment. Management wanted a series of the Rolling Stones at home, but they hated the idea of opening their private space up to strangers, particularly at a time when they were getting lots of hostile press.'

Mick Jagger gazes out defiantly from a room where the famous portrait of Bob Dylan by Milton Glaser stands amid a scattered collection of photographs, cushions and other objects. Just one of the many private moments captured by Mankowitz's lens.

Jean Marie Périer (*France, born 1940*)
Assistant to the photographer Daniel Filipacchi, in 1956 Périer began to work for *Jazz Magazine*, *Paris Match* and *Marie Claire*. After military service in Algeria, he worked from 1962 to 1974 as a photographer for *Salut les Copains*, a French teen magazine launched in 1962 by Filipacchi, who was capitalizing on his hit radio show of the same name by branching out into the world of publishing. Périer recalls: 'We were on tour in France. After the show, Mick asked me to find a car to go back to Paris because he didn't want to wait for the train. I took the whole group in the back of my car overnight, arriving at about 6 am. We went straight to my apartment, I made some tea and then I took this picture. It must have been about 8 by then.'

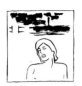
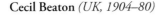

Cecil Beaton (UK, 1904–80)

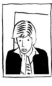

The friendship between the elegant English photographer, stage and costume designer Cecil Beaton and Mick Jagger began in the mid-sixties and is amply documented in Beaton's diaries and biography, edited by Hugo Vickers. Beaton met the singer for the first time at a ball held at Christie's. The photographer commented: 'Marvellous face. Reminds me of Nijinsky.' The pair met again by chance in Marrakech. Beaton recalled: 'I was fascinated by the thin concave lines of his body, legs, arms, mouth almost too large, but he is beautiful and ugly, feminine and masculine, a "sport", a rare phenomenon.' Beaton spirited Jagger away to photograph him among the trees and under the midday sun: 'He was a Tarzan of Piero di Cosimo.'

Mick Jagger on the set of *Performance*, the debut film by the British director Nicolas Roeg, working with Donald Cammell. It tells the story of a young gangster, pursed by the police and by his own former comrades, who hides out with a fading rock star, played by Jagger. It is a disturbing parable about power, identity, and the mystic nature of performing at the edge of madness, against a 1960s counterculture background.

'Lips of a fantastic roundness… As a model he is a natural.' The sophisticated Beaton, accustomed to working with high society and the royal family, may seem to have had little in common with Jagger the rock star, but they shared a rebellious spirit, a disdain for the conservative ethic of the previous decade, a love of provocation and a hunger for success.

Tony Frank (France, born 1945)

A photographer for *Salut les Copains* and then for *Hit Magazine*, Frank is most famed for his many hit album covers for French bands and artists, including a controversial portrait of singer Michel Polnareff with a bare backside. A great music lover, he once declared: 'We [photographers] make a living doing what we love. We don't feel like we're doing real work.'

Willie Christie (UK, born 1948)

In 1969, the Rolling Stones played a concert in Hyde Park in memory of Brian Jones, who had died shortly before. Christie was meant to photograph the band's new guitarist, Mick Taylor, but the band were not cooperative: 'They didn't want me there. I was a terrible inconvenience.' He also messed up the developing process. But when he looked through the grainy images, this moody shot of Jagger stood out and became a favourite.

Baron Wolman (USA, born 1947)

Wolman's career began in Berlin in the 1960s, with a report on life in the divided city. He then went to San Francisco where, in 1967, Jann Wenner offered him a job as photographer with a new magazine: there would be no fees at first, but this situation would be reviewed in the future. The magazine was called *Rolling Stone* and it soon became the bible of rock and pop, with Wolman as its star photographer.

1970s

Robert Whitaker *(UK, born 1939)*

British-born but with Australian heritage, Whitaker works from London and Melbourne. The favoured photographer of the Beatles, he photographed Mick Jagger in 1969 on the set of *Performance*, then followed him to Australia, where he played the legendary outlaw Ned Kelly in Tony Richardson's film of the same name.

David Montgomery *(USA, born 1939)*

In 1971, Montgomery took this carefree portrait of Mick Jagger, posing nude to promote *Sticky Fingers*, the first album to be released on the Rolling Stones' own record label. The denim-clad crotch pictured on the album's controversial cover, designed by Andy Warhol, did not belong to Jagger himself as some fans believed. The image was posed by Joe D'Alessandro, Jed Johnson, his twin brother Jay, and Corey Tippin, but it is not known which of the four is shown in the final shot.

Dominique Tarlé *(France, born 1948)*

In 1971 Tarlé was invited by Keith Richards to spend a few days at Villa Nellcôte on the Côte d'Azur, where the Stones were in tax exile. Tarlé described the time: 'A carnival of characters paraded through… dope dealers, petty thieves and hangers-on, all of them there to witness what was happening.' From the chaos and the endless nighttime recording sessions, one of the band's greatest albums was born: *Exile on Main Street*.

Ethan Russell *(USA, born 1945)*

From 1968 on, Russell was one of the closest photographers to the Stones and followed them on their 1969 US tour. 'We travelled, lived and ate together… It was all about the music.' The Stones played a free concert for fans in Altamont, California, but violence broke out in the crowd and one young man was stabbed to death. 'I was scared for my life,' Ethan recalls. After that, security was tightened and everything changed: 'The band became untouchable.'

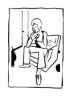

Jim Marshall *(USA, 1936–2010)*

Here is Jagger relaxing during the Stones' 1972 US tour. Marshall, a master in his field, shot some of the most memorable images in rock history. 'The music was so important to people that they want a picture to remind them of the music. Like a musician with a horn, I was there with my camera.'

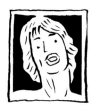

Francesco Scavullo *(USA, 1921–2004)*

A master at capturing sublime beauty, thanks to the skilful use of lighting and a talented team of hairdressers, make-up artists and stylists, Scavullo was courted by fashion magazines and celebrities who considered it a privilege to pose in front of his lens. This close-up of Mick Jagger is featured in *Song*, a portfolio of ten portraits of international music stars, from Janis Joplin to Luciano Pavarotti and Sting.

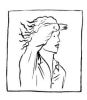

Norman Seeff *(South Africa, born 1939)*

Originally from Johannesburg, Seeff moved to Los Angeles and became famous for the photo sessions held at his Sunset Boulevard studio, which produced many iconic images. In 1971 he photographed Jagger and the Stones for the launch of the album *Exile on Main Street*, and was the art director for its cover, which was shot by Robert Frank.

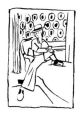

Anwar Hussein *(Tanzania)*

In 1973 the Stones played a gig at the Stadthalle in Vienna. 'Mick and I went to one of Vienna's stately homes to take a set of photographs,' says Hussein. 'We walked outside and he asked me to take a couple of pictures with his own little Instamatic. I was using transparency film at the time, which really makes the light sing. He was a joy to photograph; once he relaxed, he would pose like a model.'

Michael Putland *(UK, born 1947)*

This tireless British music photographer has shot hundreds of stars, from ABBA to Zappa. His first assignment was to photograph Mick Jagger for *Disc and Music Echo* in 1971. He later became renowned for his relationship with the Rolling Stones, which began when he photographed their 1973 European tour.

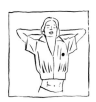

Terry O'Neill *(UK, born 1938)*

1974 was a complicated year for the Rolling Stones. The band members were living in different countries, Keith Richards's drug habit was affecting his performances, and Mick Taylor was about to leave. 'But through it all,' says Terry O'Neill, who shot him for the film *Ladies and Gentlemen: The Rolling Stones*, 'Mick worked as hard in the photo shoots as he did on stage. There was never a question of him giving you a hard time.'

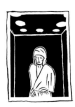

Annie Leibovitz *(USA, born 1949)*

'In 1975 Mick called and asked me if I would like to be their tour photographer... It was toward the end of the tour, and he was not on the ground. He was flying. From another world. Like a butterfly. Ethereal. I was always aware of where Mick was. What might have seemed like a nuisance to him became a source of comfort. To know that I was somewhere nearby. It was a subject–photographer relationship of an obsessive kind.'

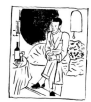

Guy Peellaert *(Belgium, 1934–2008)*

Artist, painter, illustrator, comic-book author and photographer, Peellaert is famed for his cover paintings for David Bowie's *Diamond Dogs* and the Rolling Stones' *It's Only Rock and Roll*, as well as for the cult music book *Rock Dreams* (1973). Its images portray music stars from the 1940s to the 1970s, in fictional contexts that nonetheless reflect the highs and lows and the dreams and nightmares of the music industry.

Annie Leibovitz *(USA, born 1949)*

When the Stones were rehearsing in Paul Morrissey's home in Montauk, Long Island, Jagger put his arm through a window and ended up with a nasty cut. He asked Annie Leibovitz to photograph the wound just after it had been stitched up, alongside one of the surgeon's tools, insisting that she use colour film.

Jean-Marie Périer *(France, born 1940)*

'I spent twelve years of my life with Mick, I've been everywhere with him and he let me do everything I wanted. More than anything, I'm grateful he trusted me as he did. He never asked to see a picture before it was printed – a freedom that would be inconceivable with the stars of today.'

Terry O'Neill *(UK, born 1938)*

'Back in those days, we all used to hang out in the same clubs together. The Stones, the Beatles, all sorts of models and us photographers. You have to remember that, back then, photographers were often much more important than the pop groups they photographed. If I couldn't make it down to shoot Mick and the boys one week, then they would come to me. It was that sort of arrangement.'

Ken Regan *(USA, born 1950s)*

Regan began his career as sports photographer, then became a photojournalist. He has worked with stars including Bob Dylan and has photographed the Rolling Stones on five world tours, as well as making videos and shooting portraits for magazines.

Andy Warhol *(USA, 1928–1987)*

Warhol met Mick Jagger in 1963, before he had come to fame in the US. In 1971 Warhol designed the *Sticky Fingers* album cover. The record was a huge hit and the artist, who was very money-conscious and believed that he had been paid too little for the job, wanted to take advantage of the moment to work with Jagger again. The result was a series of portraits of Mick and the album cover for *Love You Live* (1977).

1980s

Annie Leibovitz *(USA, born 1949)*

Jagger has always been body-conscious and works out even when touring. In a 1983 interview, he was asked whether he enjoyed jogging: 'Actually I torture myself just to keep in shape. I don't want to be fat, I'd rather be thin and sinewy, girls like that better.' When asked 'Do you expect to be the lead singer of the Rolling Stones in ten years time?', he replied 'Not exactly, but I'll probably be doing something equally stupid.'

Claude Gassian *(France, born 1949)*

In the late 1960s, Gassian was the singer in a rock band, but he swapped his guitar for a camera in order to get closer to his idols. When stars were passing through Paris, Gassian captured lovely moments of realism, such as this thoughtful image of Mick on a couch at the Hôtel Crillon.

Herb Ritts *(USA, 1952–2002)*

A master of black-and-white photography and a worshipper of both female and male beauty, shown to best advantage in poses inspired by Greek sculpture, Herb Ritts produced extraordinary portraits such as this image of the eternally boyish Jagger, carefree, sensual and shirtless in a circus costume.

Pierre Terrasson *(France, born 1952)*

Terrasson became a music photographer in the 1980s, when the scene was still dominated by punk and hard rock. He worked with chart-topping bands and some of the most popular French singers, from Serge Gainsbourg to Vanessa Paradis, as well as timeless stars like Mick Jagger.

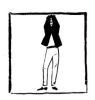

Deborah Feingold *(USA)*

She began her career working with jazz legends like Chet Baker, Miles Davis and Tony Bennett. Later, working for *Rolling Stone*, *Time* and the *New York Times*, she photographed the top names in pop culture. Feingold's pictures of Madonna from her *Desperately Seeking Susan* period were seen around the world.

Enrique Badulescu *(Mexico, born 1961)*

Badulescu studied photography in Monaco, moved to London where he worked for magazines including *The Face* and *Arena*, and then went to New York where he became a fashion photographer. In 1989 he shot Mick Jagger for *Steel Wheels*, the Rolling Stones' comeback album and tour. Badulescu used the technique known as Polaroid dye transfer, in which the layers of the image are pulled apart during developing. He said of Jagger: 'I couldn't believe how effortlessly he moved in front of the camera.'

1990s

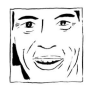

Brian Aris *(UK, born 1946)*

As the story goes, in the 1970s, Jagger decided to add dazzle to his smile by having a small emerald embedded in his upper-right incisor, but people kept mistaking it for a piece of spinach. Then he had it replaced with a ruby, but fans thought it was a drop of blood. Finally, he chose a diamond. Success at last.

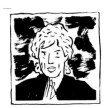

Terry O'Neill *(UK, born 1938)*

In 1969 Mick Jagger said: 'I can't do this for ever. We can't keep going on. I mean, we're so old.' He was twenty-six at the time. The band continued to perform until 1982, when they bid a temporary farewell to touring. But after a seven-year gap, they returned to the public eye with the spectacular and showstopping 'Steel Wheels/Urban Jungle' tour (1989–90).

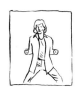

Michael Putland *(UK, born 1947)*

The 1990s signalled a major comeback for the whole band: an album every three years, followed by a tour and of course a live album. In 1997 came a new studio album, *Bridges to Babylon*, and this was followed in 2002 by the compilation *Forty Licks*, which celebrated the band's fortieth anniversary.

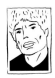

Kevin Cummins *(UK, born 1953)*

After photographing the punk scene in Manchester, Cummins moved to theatre and social photography. After moving to London in 1987, he began a long collaboration with the *NME*, and designed concert posters, album sleeves and magazine covers.

Brian Aris *(UK, born 1946)*

After a career in photojournalism, Aris set up a studio in London and devoted himself to portrait photography, most famously of British musicians from the 1960s to the 1990s. He was the official photographer for the Band Aid and Live Aid charity projects.

Anton Corbijn *(Netherlands, born 1955)*

Fascinated by the music business, Corbijn began taking photographs during concerts as a boy. In 1979 he moved to London where he shot musicians and celebrities for magazines including *Vogue*, *Rolling Stone*, *Details*, *Harper's Bazaar* and *ELLE*. These devilish images of Jagger and the fur-coat portrait were shot in Toronto, where the Stones were playing on their 'Voodoo Lounge' world tour.

Sante D'Orazio *(USA, born 1956)*

D'Orazio studied art and photography and worked for *Vogue* and then Andy Warhol's magazine *Interview*, shooting sexy images of supermodels and stars from the world of showbusiness, who were transformed into mythological beings by his lens, expressing the contemporary world's obsession with beauty, success and eternal youth.

Annie Leibovitz *(USA, born 1949)*

These shots are taken from a cover shoot for *Wandering Spirit* (1993), Jagger's third solo album, which he recorded at the age of forty-eight. They are similar but not identical to the shots eventually chosen for the cover.

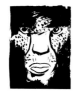

Albert Watson *(UK, born 1942)*

This unsettling portrait of Jagger as a leopard, created by means of double exposure, was first published in the 25th anniversary edition of *Rolling Stone*. Watson had originally planned to photograph Jagger in a Corvette with the leopard sitting beside him, but the concept proved too dangerous to carry out.

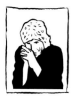
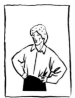

Peter Lindbergh *(Germany, born 1944)*

Peter Lindbergh was twenty-seven when he picked up a camera for the first time. He is most famous for his fashion photography and for his portrait work, which captures emotions and states of mind in a simple, natural way. These images, taken for *Rolling Stone*, reflect the self-awareness of a star at the peak of an extraordinary career.

Claude Gassian *(France, born 1949)*

Two shots from one of the European legs of the 'Voodoo Lounge' tour. Public scepticism about the advanced age of the 'boys' notwithstanding, the tour lasted for thirteen months and set box-office records.

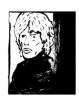

Mark Seliger *(USA, born 1959)*
Chief photographer for *Rolling Stone* from 1992 to 2002, Seliger has produced a gallery of unforgettable portraits, sometimes using unusual settings and costumes to highlight the personalities of his subjects, sometimes focusing solely on the intensity of their expressions, as in this close-up of Jagger.

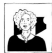

Anton Corbijn *(Netherlands, born 1955)*
Since his arrival on the music scene, androgyny, sexual ambiguity and sensuality have all played a crucial role in creating the myth of Mick Jagger. In 1996 he returned to the world of movies with a brief but memorable appearance in *Bent*, a film directed by Sean Mathias and based on the theatre play of the same name by Martin Sherman, about the persecution of homosexuals under the Nazi regime. Jagger plays the role of a drag queen, Greta/George, and features in a nightclub scene, singing 'The Streets of Berlin'. The final image was taken for *Rolling Stone* in Toronto in 2005, on the 'A Bigger Bang' tour.

2000s

Karl Lagerfeld *(Germany, born 1933)*
A fashion designer with a passion for photography, Karl Lagerfeld shot the sleeve and promo images for *Goddess in the Doorway* (2001), Mick Jagger's fourth solo album, which featured contributions from friends including Bono, Lenny Kravitz and Pete Townshend.

Mark Seliger *(USA, born 1959)*
This image is part of a series of celebrity portraits called 'In My Stairwell', taken by Mark Seliger at his New York studio. During remodelling work at the studio, an old elevator was removed, leaving the empty shaft open to the sky. The photographer decided to use this as a location for regular photoshoots, resulting in a set of powerful and iconic black-and-white images.

Simone Cecchetti *(Italy, born 1973)*
His great passion for music led Simone Cecchetti to a career as a music photographer, specializing in live performances. He always works in close contact with the artists, both on stage and off. A selection of his best work, shot in stadiums and music venues around the world, can be seen in the book *From Heart To Lens*.

Bryan Adams *(Canada, born 1959)*
Parallel to his music career, which has seen him top the charts all over the world, Bryan Adams is also a noted photographer. In 2008 he shot Jagger for *Zoo Magazine*, capturing the lean physique and energy of this still youthful sixty-four-year-old.